THEN & NOW

IRVINGTON

THEN & NOW

IRVINGTON

Judith Doolin Spikes
and Anne Marie Leone

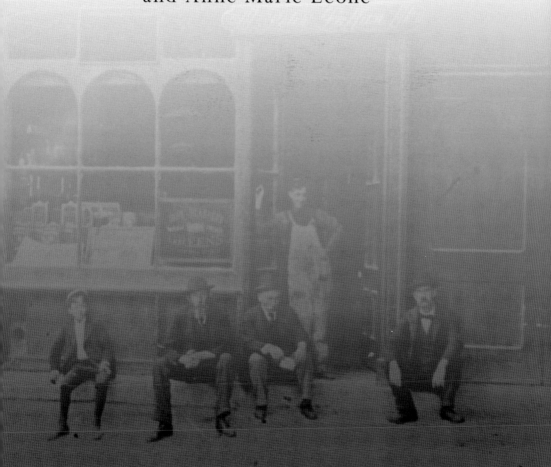

Library of Congress Control Number: 2008944220

Published by Arcadia Publishing
Charleston, South Carolina

Printed in the United States of America

For all general information contact Arcadia Publishing at:
Telephone 843-853-2070
Fax 843-853-0044
E-mail sales@arcadiapublishing.com
For customer service and orders:
Toll-Free 1-888-313-2665

Visit us on the Internet at www.arcadiapublishing.com

On the front cover: This is the iconic view of Irvington, taken from the highest point of the ridge looking down Main Street to the Hudson River. The vintage photograph was taken from the tower of the Wood Rutter mansion; the contemporary photograph is from the grounds of its replacement, Fieldpoint Condominiums. Visible in both shots are the Main Street School, the town hall bell tower, and—stretching nearly a mile into the river—the Piermont Long Dock, originally the terminus of the Erie Railroad. (Vintage photograph courtesy of the Irvington Public Library; contemporary photograph by Anne Marie Leone.)

On the back cover: Please see page 62. (Courtesy of the Irvington Public Library.)

CONTENTS

ACKNOWLEDGMENTS

This book would not exist without the encouragement of the Irvington Public Library, its governing board, professional librarians, and volunteers. Not only did they offer access to photograph and document archives but also enthusiastically joined in tracking down obscure facts. Special thanks are due to library director Pam Strachan and reference librarian Betsy Sadewhite.

We are grateful to Barbara Denyer, Betsy Sadewhite, Pam Strachan, and Benita Roumanis for giving the book a critical reading. It is much the better for their attentions, and so are we. All remaining errors of fact or judgment are solely our own.

Vintage photographs are primarily from the Irvington Public Library, supplemented by collections of the Ardsley Country Club, Patricia Arone, Jane Faber, and Ed Tishelman; other individuals lent an image or two. The Historical Society of the Tarrytowns, Westchester County Archives, and Westchester County Historical Society generously extended access to their archives.

Our understanding of Irvington is based on *Wolfert's Roost: Irvington-on-Hudson*, a self-described "communal effort" to "sketch a portrait of the village, not to write its history." A work of such charm, readability, and community spirit can have no peer. We have sought to make our contribution by supplying specific dates and names, as well as places, wherever possible.

Among the published sources we consulted are the *Irvington Gazette* (1907–1969), *Rivertowns Enterprise* (1970–present), the *New York Times* (1851–present), and the *Roost*, the newsletter of the Irvington Historical Society. We are also indebted to the standard 19th-century histories of Westchester County by Robert Bolton, Alvah P. French, Thomas Scharf, and Frederic Shonnard and W. W. Spooner, as well as such modern works as Frank Sanchis's *American Architecture: Westchester County, New York* (1977); *Westchester: The American Suburb*, edited by Roger Panetta (2006); Kate Buford's *From Hudson to Hilltop: Time, Change, and the Ardsley Country Club* (1997); and Carolyn G. Stifel's *The Church of St. Barnabas: Its History and Windows* (2008), which contains, in addition to its stated subject, much biographical and social history.

What one can know of the past depends on what survives into the present. We apologize to the historically and architecturally significant sites excluded for lack of a high-quality vintage image.

Unless otherwise noted, all vintage images are courtesy of the Irvington Public Library and all contemporary images are by Anne Marie Leone.

INTRODUCTION

In 1609, Henry Hudson sailed up the river that now bears his name on a voyage of discovery financed by the Dutch East India Company. He encountered scattered members of an Algonkian-speaking tribe in the region that since 1872 has included the incorporated village of Irvington.

Four decades passed before permanent Dutch settlers arrived, initiating the era of farms both great and small. In 1664, the Dutch ceded the New Netherlands colony to their English rivals. Building on the patroon system of land ownership, the English created six great manors in Westchester County. The history of Irvington is rooted in the 92,000-acre manor chartered in 1693 to Frederick Philipse as a provisioning plantation for the transatlantic trade in grain, sugar, rum, and enslaved Africans; the village boundaries nearly enclose four of the Philipsburg Manor tenant farms of approximately 500 acres each.

Descendants of the original tenants of those four farms—Jan Harmse, John Buckhout, Barent Dutcher, and Wolfert Ecker—remained on the farms for generations. During the American Revolution, they were trapped in a nominally neutral but lawless area between British forces in the Bronx and American troops in northern Westchester. Repeatedly overrun and preyed upon by both sides, many inhabitants fled to safer areas, leaving their homes in the care of servants and slaves. After the war, the lands of Frederick Philipse III, a loyalist, were seized by New York State and sold in 1779 to their tenants, who typically retained a plot of 100 or so acres for themselves and sold the rest to investors. Thus the boundaries of the four farms—stretching from the Hudson River east across the old Albany Post Road, now Broadway, to the Sawmill River, and from Dobbs Ferry north to Tarrytown—set the perimeters for development of the Irvington area, from the gentlemen's farms of the early 19th century through the country estates of Gilded Age industrialists and financiers to early-20th-century residential parks, and later condominium town houses for commuters.

In the early 19th century, epidemics of yellow and typhoid fever—due to pollution of wells by privies—inspired a rush from the city to country homes by all who could afford them. About 1835, Alexander Hamilton's son James purchased a 154-acre parcel of the former Harmse farm from Stephen B. Tompkins, the son of another prominent Revolutionary-era figure. James Hamilton is typical of the first postwar generation to acquire a countryseat in Irvington. In the same decade, Washington Irving, America's first man of letters, purchased Wolfert Ecker's Colonial-era farmhouse 1.6 miles north.

Construction of the Croton Aqueduct parallel to Broadway began in 1837, disrupting farming for five years, and the arrival of the railroad in 1849 virtually ended it. "Since the Hudson River [rail] Road has commenced running," the *New York Times* reported in 1853, "land has risen to a price at which farming on the most improved principles would fail to be remunerative . . . delightful scenery and fresh air [are] brought within an hour's ride of our city, and businessmen are enabled to join their families at the evening and morning meal in their pleasant, healthful homes." The price of land had risen from $30 an acre in 1843 to between $1,000 and $2,000, the newspaper added.

Cyrus W. Field, builder of the transatlantic cable who bought much of the Harmse farm in 1869, represents the semiretired industrialists and financiers who began to arrive after the railroad and the Civil War. Whereas the early-19th-century estates were built along the Hudson River, newcomers favored the heights east of Broadway, which offered both panoramic views of the Hudson River and isolation from the noise and disruption of trains and the new industries growing up on the waterfront. Whether new rich or old, those who built castles and chateaus on parklike grounds were, by the end of the 19th century, largely related by blood, marriage, and corporate-board or social-club membership, and they were catered to by a class of merchants, tradesmen, and servants whose descendants remained into the 20th century to form the backbone of the community.

The commercial district—Main Street and its alphabetically named cross streets—was centered on the dock and depot. It grew up in the half century following the 1850 subdivision by land speculators of the Dearman portion of the Dutcher farm. When a post office and a railroad station were established in 1854, they were named Irvington in honor of America's favorite author, who lived in the community until his death in 1859. Irving's renown and that of the new American School of Hudson River painting combined to place the area among the most popular tourist destinations in America. Irvington became an incorporated village within the town of Greenburgh in 1872 just two years after the incorporation of the neighboring hamlet of Tarrytown annexed Irving's home site, along with a dozen neighboring grand estates.

Electrification of the railroad in 1912 brought Grand Central Terminal just 35 minutes away, and Irvington gradually took on the character of a commuter suburb. Breaking the old estates into residential parks, apartment complexes, and condominiums began. First came development of the aristocratic Ardsley, Tiffany, and Matthiessen park neighborhoods, with their private roads winding through extensive grounds, followed by subdivision of the smaller estates into comparatively modest dwellings.

The Depression inspired the first apartment building, Hudson House, which was erected in 1936 on the site of the Ardsley Club casino while retaining the club's covered walkway to its very own train station. Several of the grandest mansions fell to the wrecker's ball over the next decade, as property and income taxes soared and plutocrats' fortunes declined. The water-view Half Moon Apartments, partially funded by the Federal Housing Authority, went on the market with preference to veterans in 1952. Five more garden-type apartment buildings were constructed on former estate property along Broadway.

Few palaces survived the economic downturn of the 1970s. In the 1980s, as Irvington's population reached 6,500, almost all the remaining villas and arboretums were replaced by town house condominiums and cluster housing. And yet, Broadway, from one end of the village to the other, is still lined with the stone walls and noble trees of the vanished estates, and on an early Sunday morning in winter, with no cars at the curb or leaves on the trees and most of the small shops and houses still in place, the vista down Main Street to the Hudson River is little changed from that of a century ago.

EXPLORING SOUTH BROADWAY

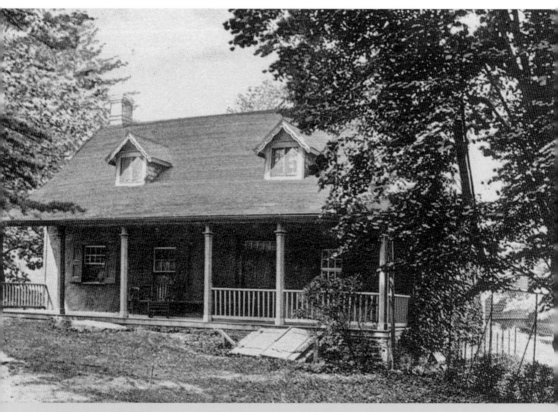

This farmhouse on Broadway at the corner of Dows Lane entered history in 1693 as the home of Philipsburg Manor tenant Jan Harmse. It was the focus of local Revolutionary War activity when operated as a tavern by a Harmse successor and kinsman, Jonathan Odell. Photographed about 1920, the venerable structure, the oldest in Irvington, remains on its original site. (Courtesy of Patricia Arone.)

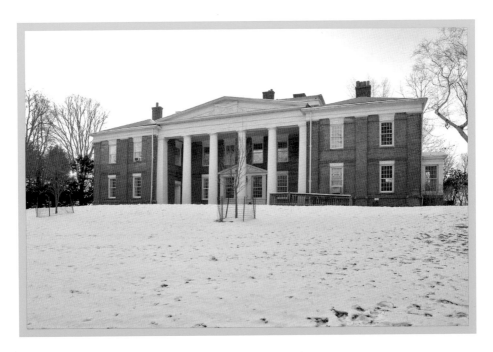

Stephen Tompkins bought 300 acres of the Odell farm in 1818 and sold half in 1835 to James Hamilton, who built a home named Nevis after the birthplace of his father, Alexander Hamilton. Remodeled in 1886, as seen here, the mansion at 136 South Broadway remained in the family until 1917. Purchased by T. Coleman DuPont in 1920, donated to Columbia University in 1935, and converted to a nuclear research facility, by 1947 Nevis housed the largest proton accelerator in the world.

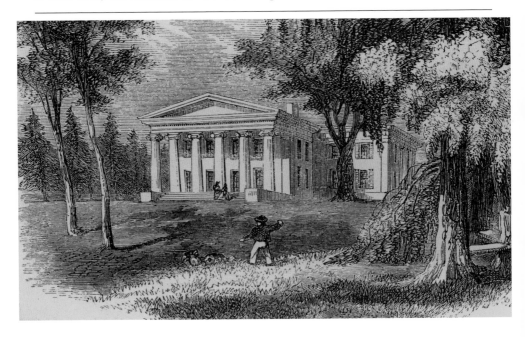

The Old Croton Aqueduct Trail runs atop the 41-mile masonry conduit built between 1837 and 1842 by Irish immigrant laborers to carry water from the Croton Reservoir to New York City. One of the largest engineering projects of its time, the tunnel was closed in 1965. The trail, shown here near Nevis in 1886, runs through the village from north to south between Broadway on the east and the Hudson River on the west. The vintage photograph is dated 1886. The Old Croton Aqueduct is listed on the National Register of Historic Places.

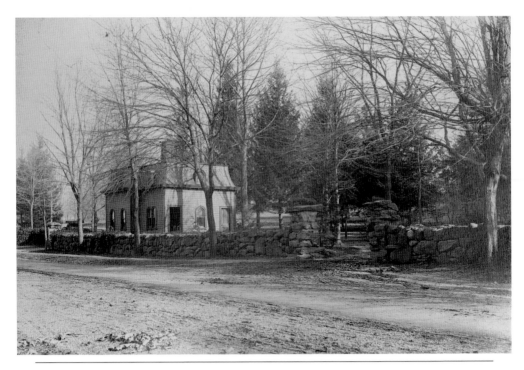

The 1870 gatehouse at 163 South Broadway, photographed in 1888 and now used as a residence, marked the entrance to the vast hilltop estate of Cyrus W. Field. Field made an early fortune in paper wholesaling, then achieved lasting fame in 1866 when, after several failed attempts, he succeeded in laying a telegraph cable across the floor of the Atlantic Ocean, thereby shortening communication time between the United States and Europe by two weeks. He named his estate Ardsley after an ancestor's birthplace in England. (Vintage photograph courtesy of Special Collections, Kuhn Library, University of Maryland-Baltimore County.)

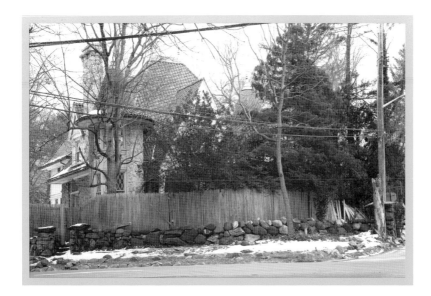

Four years after Field's death in 1892, Amzi Lorenzo Barber acquired Ardsley Towers, a Field family mansion on 400 acres. In 1899, he remodeled its gatehouse into this fanciful structure at 3 East Ardsley Avenue and began development of Ardsley Park, with the Ardsley Club as an attraction. A philosophy professor at Howard University in early life, Barber, "the asphalt king," made his fortune paving the avenues of Manhattan, Washington, D.C., and beyond.

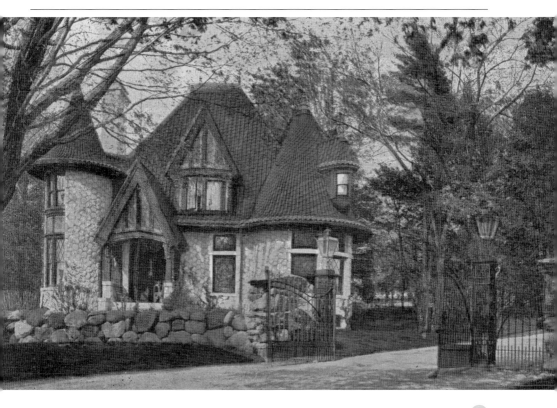

The reclusive, wildly eccentric John Gottlieb Wendel family, who for 80 years owned the Abbotsford mansion house and the Odell Tavern at 100 South Broadway, were the largest holders of Manhattan real estate next to their in-laws the Astors. Miss Ella, the last family member, died in 1931 and willed most of her $36 million to charity. The daughter of her will's executor received the Irvington property, razed the mansion in 1938, and commissioned another one from Aymar Embury II, architect of the George Washington Bridge.

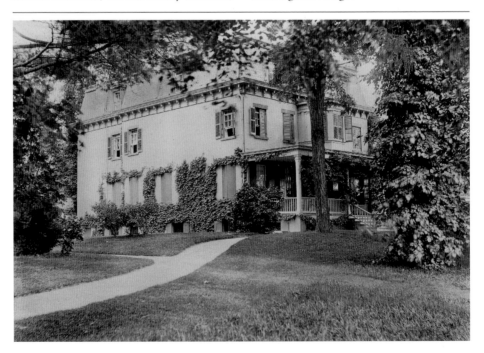

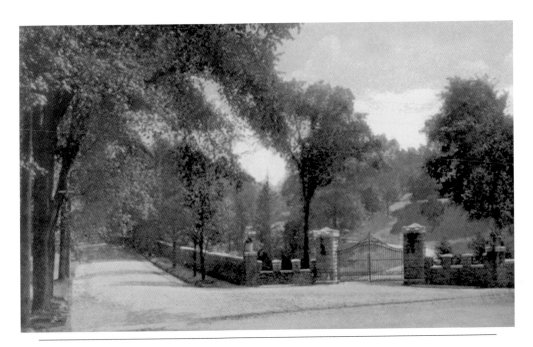

The stone walls and entrance gate at the southeast corner of Broadway and Harriman Road, photographed about 1905, are all that remain of three magnificent estates carved out of the 200-acre gentleman's farm of dry goods merchant Charles Harriman. Those estates, belonging to Gen. S. H. Chamberlain, Dr. Lucien Warner (Cromont), and Daniel Gray Reid (Richmond Terrace), are presented on the next three pages. (Vintage photograph courtesy of Patricia Arone.)

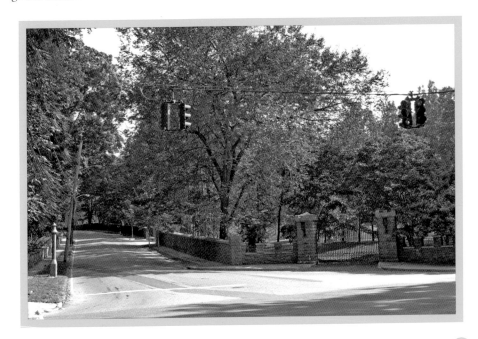

After Charles Harriman's death in 1878, Gen. S. H. Chamberlain purchased his residence and several acres along the east side of Broadway south of Harriman Road and erected a grand mansard-roofed mansion on the hillside, shown here in 1900. A Miss Bennett bought both dwellings around 1891, demolished Harriman's, and founded a school for young ladies in Chamberlain's. When Daniel Gray Reid bought the property in 1907, the school moved to Millbrook in Dutchess County. (Vintage photograph courtesy of Jane Faber.)

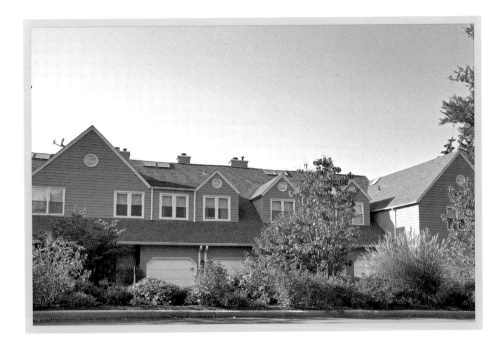

Reid was known as "the tin plate king," although he also had holdings in railroads and steel. Upon buying and demolishing the Bennett School, he also bought the adjacent 1892 mansion of Dr. Lucien Warner ("the corset king," founder of the undergarment company that still bears his name) and purchased eight forested acres across Broadway to preserve his view. He enlarged Warner's mansion in 1902, as seen here in 1929. It stood on the approximate site of 16–18 Richmond Hill.

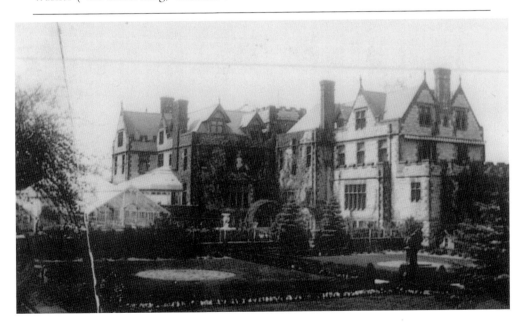

Daniel Gray Reid renamed the estate Richmond Terrace after his Indiana birthplace. Pictured here in 1909 is the interior courtyard known as Garden of the Lions (facing the garage–cum–clock tower). Owners following Reid's death in 1925 included stockbroker William Mitchell and, in 1930, American Tobacco Company president George Washington Hill. Subsequently becoming a Philips Corporation laboratory and then a Hasidic rabbinical school, the mansion burned in 1978 and was replaced in 1985 by the Richmond Hill condominiums. Seen here are 31–33 Richmond Hill. (Vintage photograph courtesy of Jane Faber.)

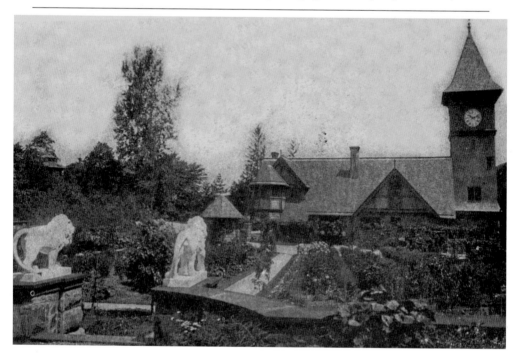

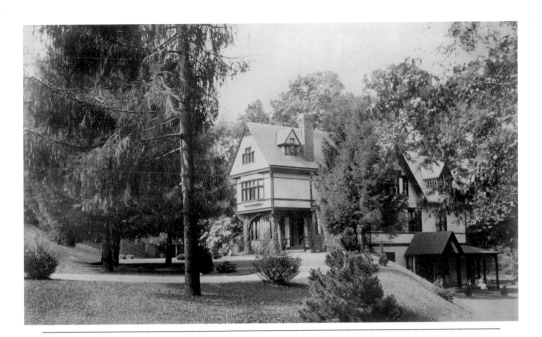

Reid's eight acres of forest, meadow, and ravine west of Broadway between Station Road and Dows Lane have comprised Memorial Park since 1929. The Station Road playground occupies this home site, photographed in 1889. It was known as Springbrook Cottage on the Barney Estate when architect Alfred J. Manning and his bride moved there in 1885. Town hall was among Manning's Irvington designs.

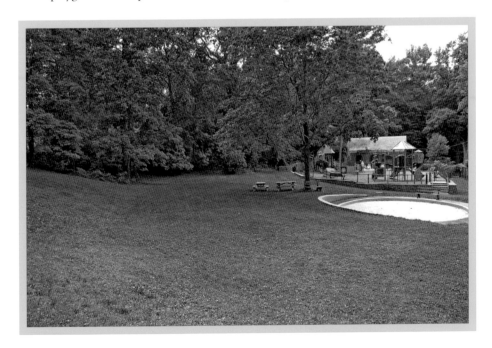

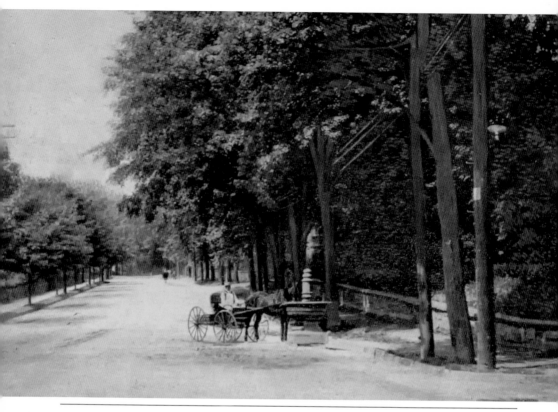

A stylish Irvingtonian out for a drive in 1907 pauses on Broadway just north of Harriman Road at the marble fountain, a watering place for horses and dogs. Installed in 1889 as a memorial to beloved village doctor Isaiah Ashton, the fountain was moved in 1954 and now rests in front of town hall. In the 19th century, the stretch of Broadway through Irvington was known as "millionaires' mile," with stone walls bounding the great estates along both sides.

In 1888, James Henry Whitehouse bought Miss Halpine's private school—originally the 1860s estate of James L. Adams—at 35 South Broadway, restored it as a home, and named it the Larches. It is seen here in 1912. Partner in the oldest brokerage firm on Wall Street, Whitehouse was a member of the exchange for 66 years. The estate was auctioned in 1928; its replacement, Cedar Hill Apartments, was erected 1951. During demolition, a mysterious underground chamber discovered on the property was quickly filled in. (Vintage photograph courtesy of Patricia Arone.)

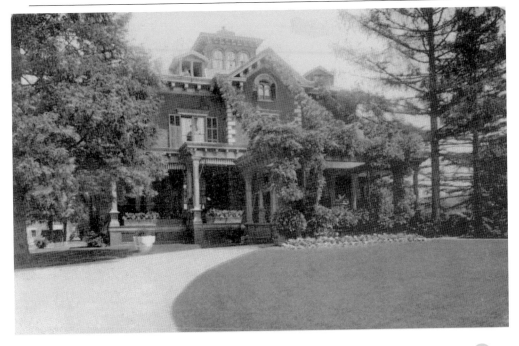

Redwood, built in the late 1870s and seen here around 1908, was razed in 1943 after standing vacant for a decade. It was the home of William Addison Burnham, partner and son-in-law of Frederic Allan Lord. Based in Irvington, the Lord and Burnham firm erected one of the first steel-framed curvilinear greenhouses in America on Jay Gould's nearby estate in 1881. The Irvington Estates apartment buildings at 14 South Broadway, which opened in 1948 and gave preference to veterans, now occupy the site. (Vintage photograph courtesy of Patricia Arone.)

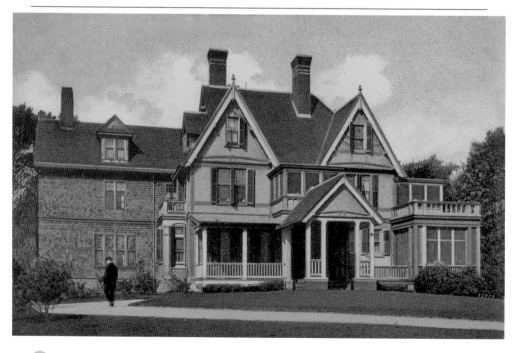

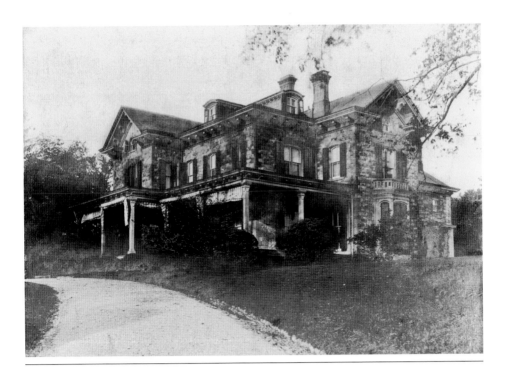

Produce tycoon Frederick Guiteau built this home in 1869 on 14 hillside acres. A member of the school and village boards and founder of the Irvington Public Library, Guiteau bequeathed his estate to Cornell University in 1903. This photograph was taken before 1918 when the mansion was sold to insurance broker Moses Tanenbaum and completely remodeled. It stood until 30 years after his death in 1937 on what is now Dogwood Lane in the High Gate subdivision.

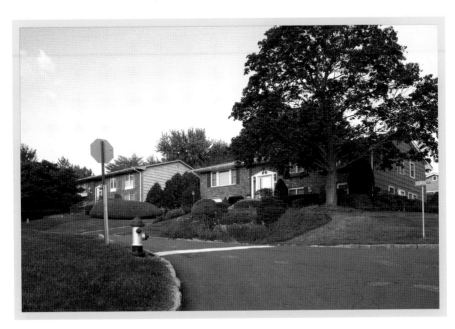

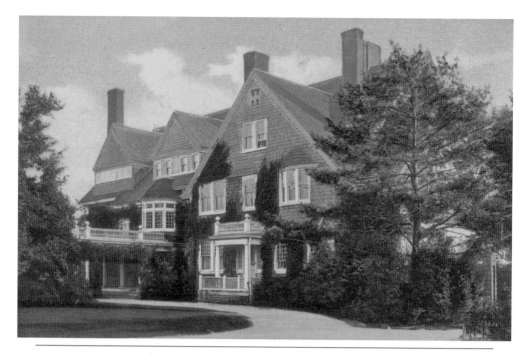

Dr. Carroll Dunham, an in-law of Charles Lewis Tiffany, kin to a famed homeopathic physician of the same name, and husband of Margaret Dows, built Hillside at 30 South Broadway in 1889. Seen here in 1920, Hillside was sold in 1922 to Gordon Harris, a son of the Baltimore and Ohio Railroad president. Abandoned during World War II, Hillside was purchased in 1946 by Leonard Read and remains the headquarters of Read's Foundation for Economic Education. (Vintage photograph courtesy of Patricia Arone.)

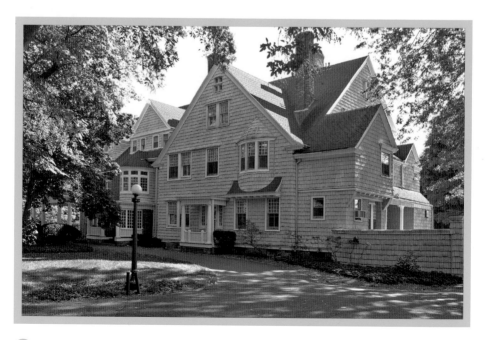

WEST OF SOUTH BROADWAY ALONG THE HUDSON

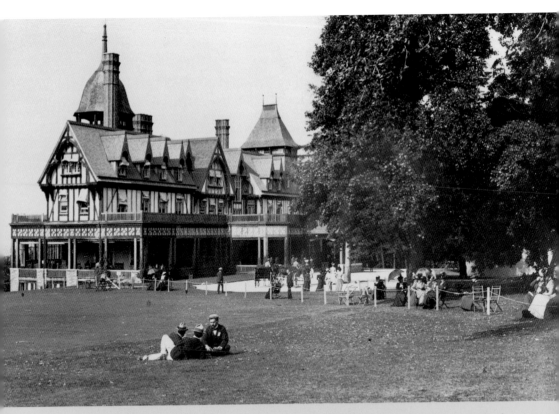

The Ardsley Club casino, photographed in 1898, was constructed in 1896. One of the first country clubs in the United States, it was a playground for the East Coast elite. The club shared its driveway (now West Ardsley Avenue) and the land west of Broadway with a few grand estates. Named for Cyrus W. Field's estate, the club was the centerpiece of a land development project. (Courtesy of Ardsley Country Club.)

In 1895, the New York Central and Hudson River Railroad created the Ardsley-on-Hudson stop as a favor to the Ardsley Club syndicators. These included Cornelius Vanderbilt II, grandson of the railroad's founder; and Chauncey Depew, its president; road-building tycoon Amzi Lorenzo Barber; journalist and financier Henry Villard; J. P. Morgan; John D. and William Rockefeller; and Philip Schuyler, a Civil War general and Hamilton kinsman. Club members retained exclusive use for many years. The vintage photograph is from 1905. (Vintage photograph courtesy of Ardsley Country Club.)

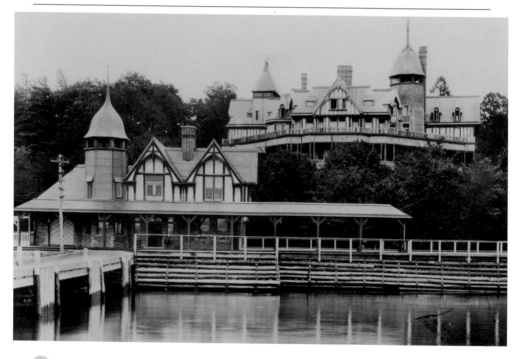

WEST OF SOUTH BROADWAY ALONG THE HUDSON

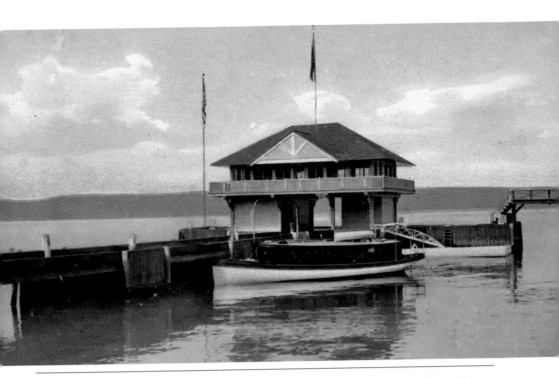

From the Ardsley-on-Hudson railroad station, a private dock, pictured here in 1908, extended into the Hudson River. This was provisioning station No. 9 of the New York Yacht Club, which shared many members with the Ardsley Club. Steam yachts large enough to cross the Atlantic Ocean anchored here, and gentlemen of the club commuted to New York City from their summer homes by water until the Depression put an end to such luxuries. (Vintage photograph courtesy of Edward Tishelman.)

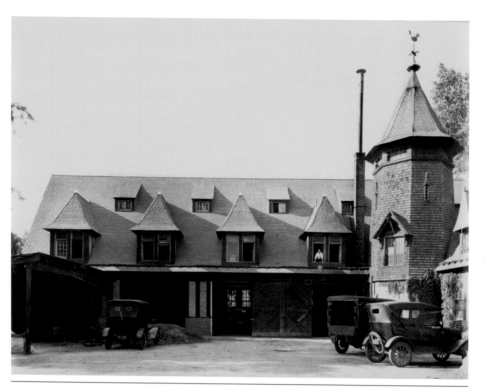

Felled by the Depression, the Ardsley Club merged in 1935 with the Racquet and Swimming Club, sold the casino to developers, moved into its stables (seen here in 1915), and took the name Ardsley Country Club. The Hudson House Apartments, designed by Empire State Building architects Shreve, Lamb and Harmon, replaced the casino in 1936. The club moved again in 1966, and the stables are now a two-family residence at 61–63 West Ardsley Avenue. (Vintage photograph courtesy of Ardsley Country Club.)

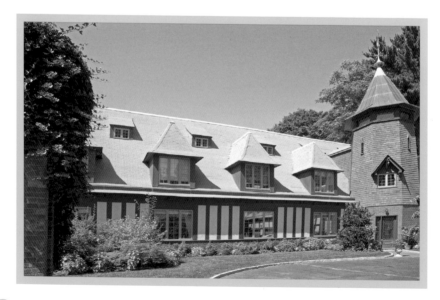

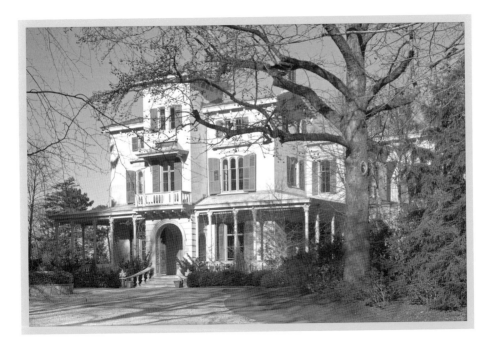

Textile importer Francois Cottenet, a partner of neighbor Charles Harriman, built his 1853 villa of stone from the French Cote d'Or and named it after his birthplace, Nuits St. Georges. The villa is one of six yellow-stone mansions built at about the same time in Irvington. Pictured in 1926, Nuits survives on four acres at 2 Clifton Place, protected by deed restrictions imposed by Cyrus W. Field during his brief ownership (1886–1887), after which he sold the estate to John Jacob Astor III. Nuits is listed on the National Register of Historic Places.

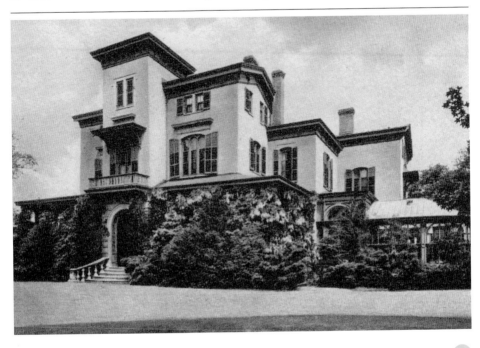

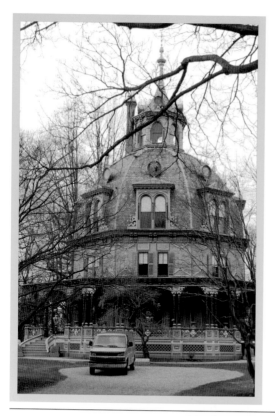

The 1860 Octagon House was built at 45 West Clinton Avenue for financier Paul J. Armour. In 1872, Joseph Stiner, the world's largest tea retailer, added the two-story dome and wraparound verandas, creating a building unique in the world, as seen here in 1885. Author-historian Carl Carmer owned it between 1946 and 1976, when it was purchased by the National Trust for Historic Preservation and resold to architect Joseph Pell Lombardi on his promise to restore it—a goal he has faithfully pursued for three decades. The Armour-Stiner House is a national historic landmark and is listed on the National Register of Historic Places. (Vintage photograph courtesy of Joseph Pell Lombardi.)

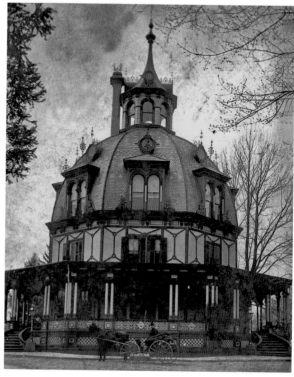

WEST OF SOUTH BROADWAY ALONG THE HUDSON

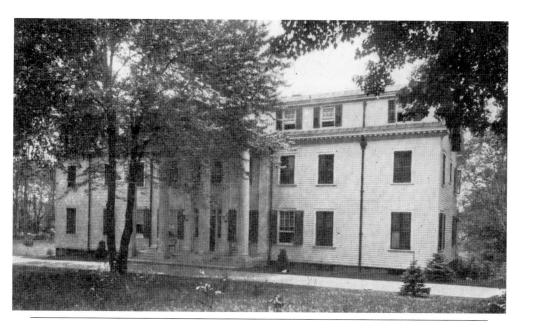

William Gibbs McAdoo built 65 West Clinton Avenue, seen here in 1913. McAdoo constructed the first passenger railroad tunnels under the Hudson River in 1908, reducing travel between Manhattan and Hoboken, New Jersey, from 32 minutes by ferry to 8 minutes via his electric railroad, the Hudson and Manhattan, which is now part of the Port Authority Trans-Hudson (PATH) system. In contrast to his robber-baron peers, McAdoo's motto was "Let the public be pleased." Tapped by Pres. Woodrow Wilson for treasury secretary in 1913, McAdoo averted a global financial collapse during World War I. (Vintage photograph courtesy of Edward Tishelman.)

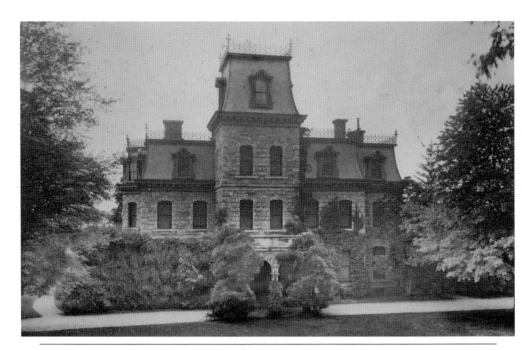

David Dows, a produce broker, banker, and railroad director, bought 32 riverfront acres in 1868 and erected a stone mansion resembling one his partner and nephew, John Dows Mairs, owned nearby. Named for Dows's New York birthplace and seen here in 1900, Charlton Hall and its parklike grounds remained in the family until it was sold in 1913 to Adam K. Luke, a director of banks and insurance companies and of his family's West Virginia Pulp and Paper Company. A school soccer field now occupies the site. (Vintage photograph courtesy of Barbara Denyer.)

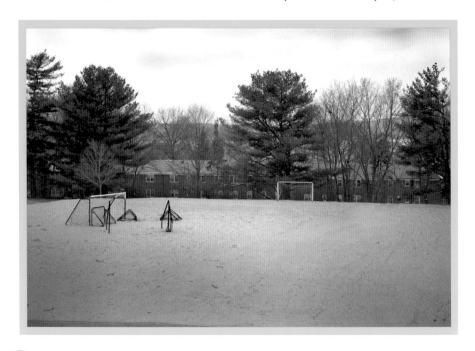

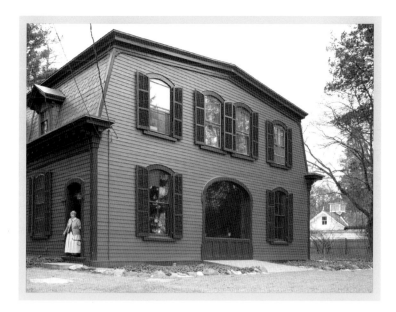

Luke suffered reverses during the Depression and put the estate (renamed Devon Hall) on the market in 1940. A year later, angered by the lack of a buyer and rising real estate taxes, he had the mansion destroyed. Photographed in 1950, the carriage house, described in the sales brochure as a garage for 10 cars and seven horse stalls with a chauffeur's apartment and haylofts above, was converted into a residence at 7 Dows Lane by artist Jack Sparrow. (Vintage photograph courtesy of Barbara Denyer.)

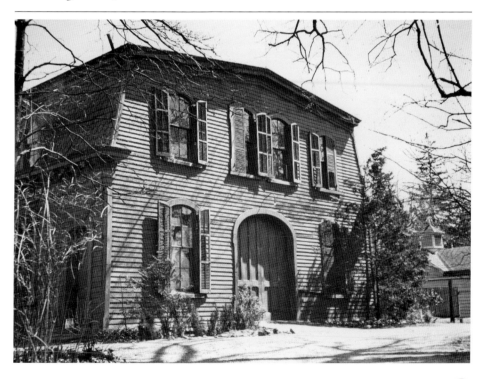

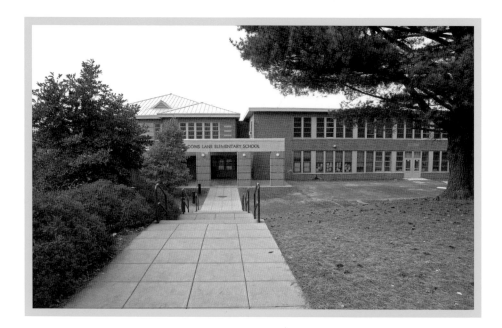

John Mairs bought Lynwood around 1867 from boot wholesaler Asa G. Trask, whose fortunes had fallen with the Confederacy. Part of the property passed to his son Edwin Hays Mairs in 1885. By 1914, John Mairs's daughter Mary, wife of Rev. John B. Calvert, owned Lynwood. It was razed in 1940. The 217-unit Half Moon Apartments were built on 19 acres of the Mairs and Dows estates in 1952. Dows Lane School opened in 1955 on Lynwood's site; its carriage house survives as a private home.

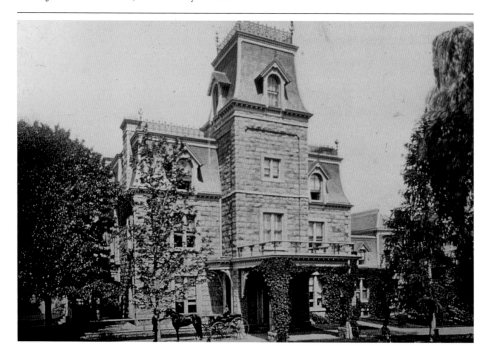

WEST OF SOUTH BROADWAY ALONG THE HUDSON

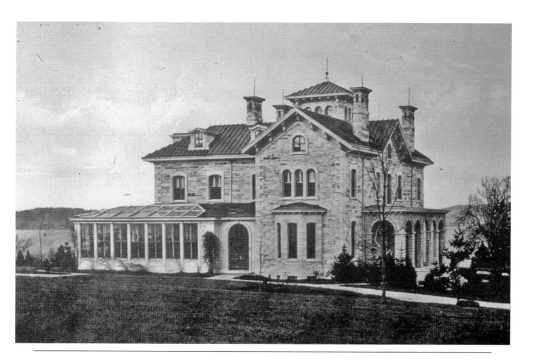

In 1860, Danford Newton Barney, president of Wells Fargo and a founder of American Express, purchased silk wholesaler Theodore McNamee's yellow-stone mansion, Rosedale, on 30 acres overlooking the Hudson River. Rosedale, with its east facade shown here in 1865, stood south of Station Road between Maple and Willow Streets. It was razed in 1928 after the property was subdivided as Spiro Park. Salvaged stone was used at 27 Maple Street, seen below.

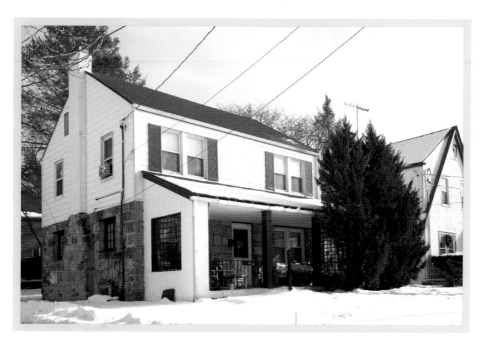

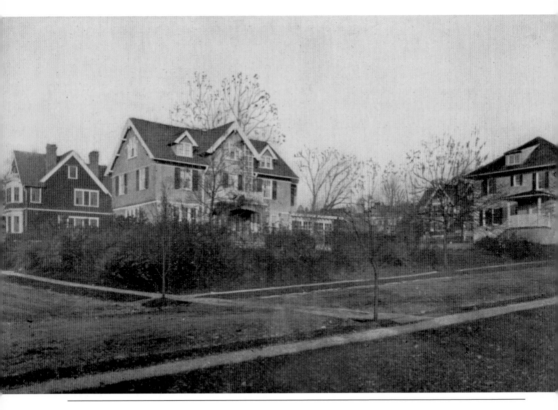

The 1890s Barney Park subdivision, shown here in 1920 at the corner where South Cottenet Street turns eastward, recalls the Barney family's 70-year presence in the village. Station Road and its tunnel formerly bore the Barney name. The Lindens, located nearby at 54 Jaffray Court, was built in 1870 for Danford Newton Barney's son Newcomb Cushman Barney, whose niece Azuba inherited the house and married Reginald Jaffray. The property's eight surrounding acres were subdivided as Jaffray Park in 1950.

CHAPTER 3

EAST OF SOUTH BROADWAY ALONG THE RIDGE

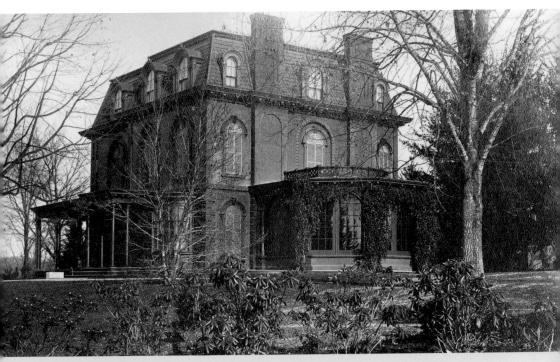

In 1869, Cyrus W. Field bought this mansion—thereafter known as the Homestead—on 20 acres near Irvington's southern border. The seller was Alexander T. Stewart, founder of the first American department store, for whom Field had worked as a clerk at age 15. The Homestead, photographed in 1888, stood between 49 and 55 Field Terrace until destroyed by fire in 1978. (Courtesy of Special Collections, Kuhn Library, University of Maryland–Baltimore County.)

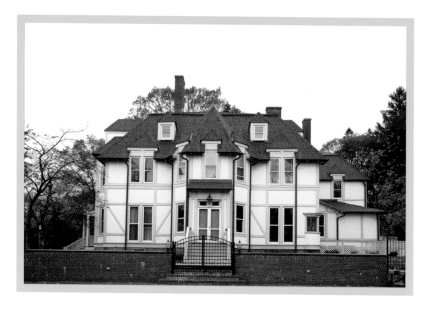

By 1886, Cyrus W. Field's estate had grown to over one square mile and was adorned with six family mansions and a dozen elaborate accessory buildings. Two of the mansions survive, including Inanda at 65 Field Terrace. Home of Field's daughter Mary Grace from 1874 until 1891, Inanda, seen here in 1888, is named for a town in her husband Daniel Lindley's native South Africa. Its name signifies "pleasant place" in Zulu. Later owners included diva Lillian Nordica in 1907 and Amzi Lorenzo Barber's daughter Lorena Davis in 1926. (Vintage photograph courtesy of Special Collections, Kuhn Library, University of Maryland–Baltimore County.)

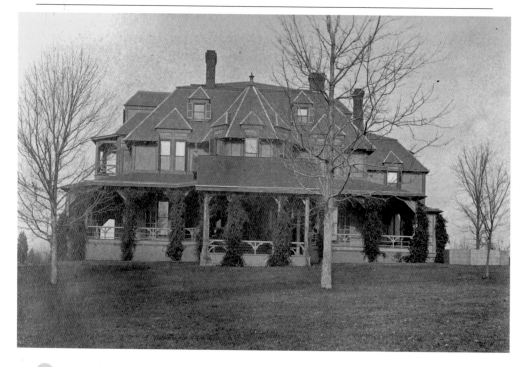

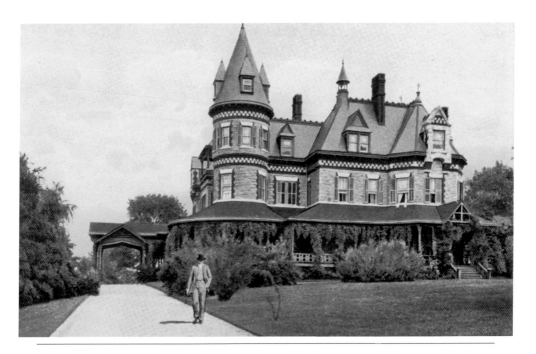

"Can such things be!" was the overawed reaction of a reporter to his first sight of Ardsley Towers, built for Cyrus W. Field Jr. about 1882 on the highest point of the estate. Following the elder Cyrus W. Field's death in 1892, Amzi Lorenzo Barber formed the Lorena Company to develop Ardsley Park. His heirs razed Ardsley Towers, seen in this 1908 photograph, during construction of the second phase of the subdivision in 1928. The backyard pool of 55 Field Terrace now occupies its site. (Vintage photograph courtesy of Patricia Arone.)

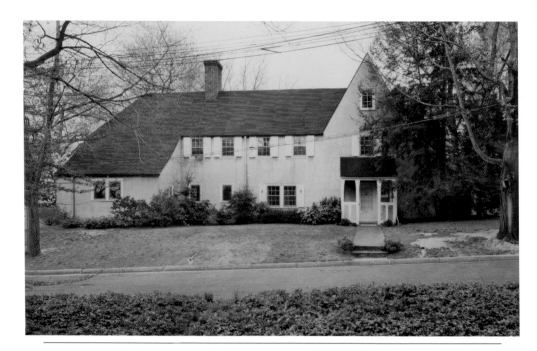

Photographed in 1930, 24 Erie Street is typical of dwellings built in Ardsley Park in the 1920s—luxurious year-round homes with ample grounds for well-to-do commuters that replaced the palatial estates of 19th-century moguls. In 1910, this lot was part of a 2.5-acre parcel owned by Franklin Q. Brown, president of the Dobbs Ferry Bank and the Ardsley Club. Brown's son-in-law architect Leigh H. French Jr. owned the lot from 1922 to 1926; conjecture is he built the house, for himself or a client, in 1928. (Vintage photograph courtesy of Joan and Tom Rothman.)

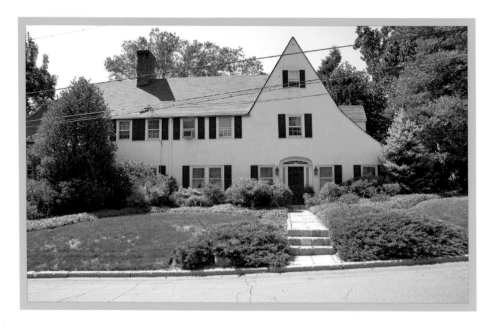

EAST OF SOUTH BROADWAY ALONG THE RIDGE

Justine Ward, inventor of a system of music education based on liturgical chant, built Mora Vocis at the east end of North Mountain Drive in 1926. Designed by architects Delano and Aldrich as a miniature of the Benedictine Abbey in Solesmes, France, it was subsequently owned by nonresident Frank Jay Gould and became the home of the Ardsley Country Club in 1965. The southern facade, photographed in 1927, is shown here. (Vintage photograph courtesy of Ardsley Country Club.)

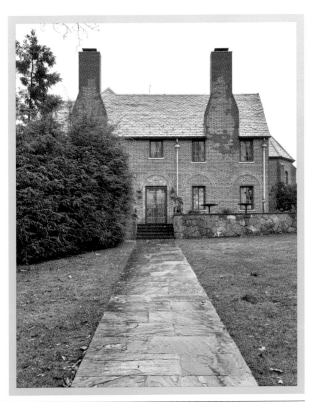

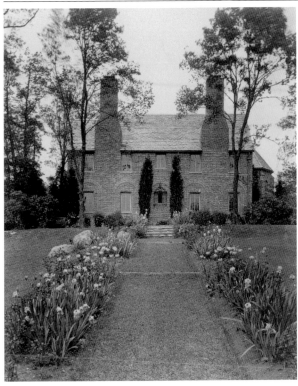

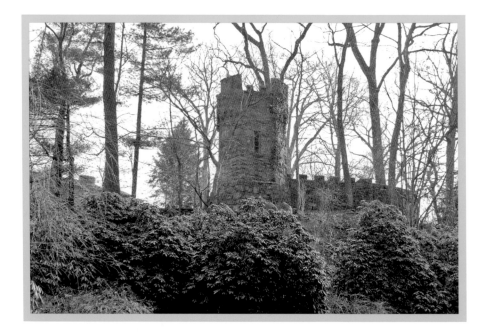

Melchior Beltzhoover, a cotton and oil millionaire from Mississippi who served as president of Irvington for 13 years, built this castle on 200 acres north of Ardsley Park in 1905. The photograph dates from 1910. Designed by A. J. Manning, Rochroane was sold in 1927 to Benjamin Schuyler Halsey, vice president of Sheffield Farms, who renamed it Grey Towers. Ruins remain at the dead end of Castle Road and are best seen looking up from the southeast corner of Park and Palliser Roads. (Vintage photograph courtesy of Patricia Arone.)

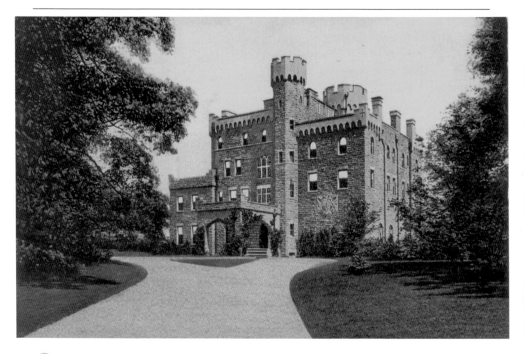

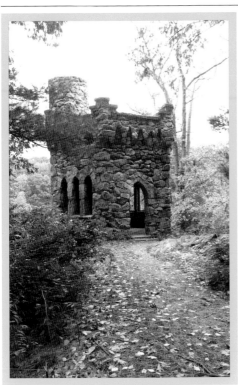

c. 1912

After Halsey's death in 1956, his widow began donating portions of the estate to Immaculate Conception Church, ending with the mansion itself in 1976. Gutted by fire a few months later, the mansion and 38 acres were sold to a developer who, in 1980, deeded Halsey Pond and its folly, sometimes called Halsey Teahouse, to the village in exchange for permission to remove Rochroane/Grey Towers and subdivide the rest of the property. The teahouse is seen here about 1912. (Vintage photograph courtesy of Patricia Arone.)

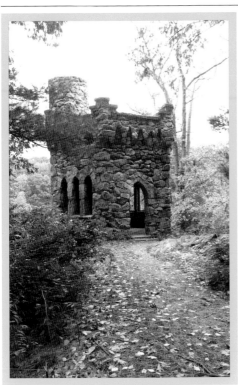

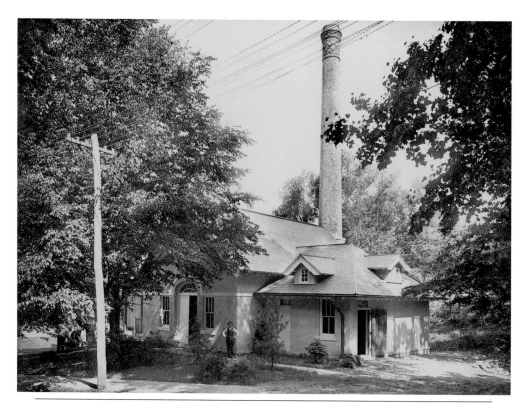

The Irvington Water Works began in 1883 with a 600-foot artesian well filling a one-acre reservoir (now part of the Legend Hollow development). This building at 109 Harriman Road, photographed in 1920, served as pump house until 1929. Subsequently used by the Department of Public Works and the Boy Scouts, it has been a residence since 1990. A new pump house built on Station Road in 1934 tapped the Old Croton Aqueduct as an additional supply until 1965.

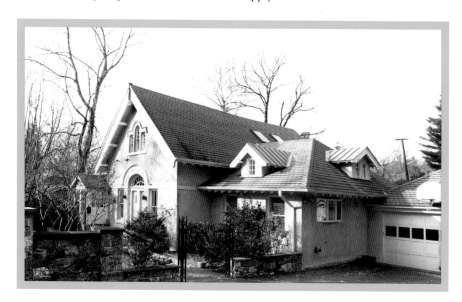

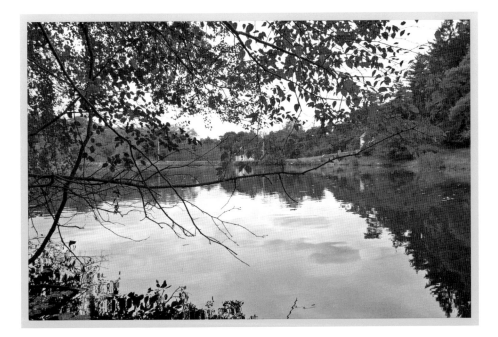

Photographed in 1908, the Irvington Reservoir at the top of Harriman Road was completed in 1900. Before public water was available, the great estates had their own well- or spring-fed reservoirs, which doubled as ice ponds in winter. Smaller residences and commercial establishments pumped well water into attic storage tanks for drinking and collected rainwater in cisterns for other purposes. (Vintage photograph courtesy of Patricia Arone.)

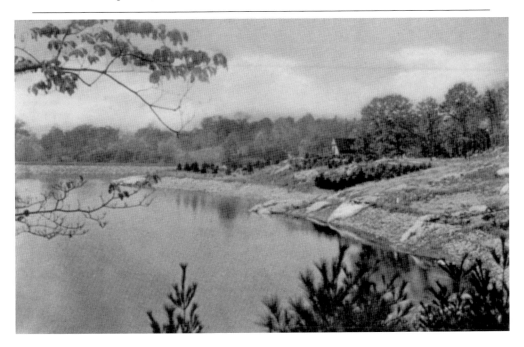

Built sometime in the 1870s, the Behrens homestead, photographed in 1905, was moved to 254 Harriman Road in 1898 when its original site was flooded for the new Irvington Reservoir. The stepped-gable stone dwelling at left (8 Cyrus Field Road) was its carriage house. Builders and building inspectors with the Behrens surname appeared in village records for generations, and family members occupied this property until 1968. (Vintage photograph courtesy of William and Kathleen Moss.)

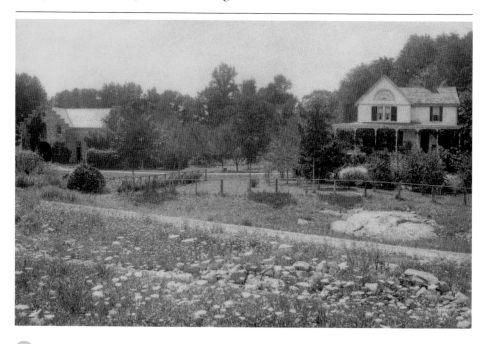

STROLLING MAIN AND THE ALPHABET STREETS

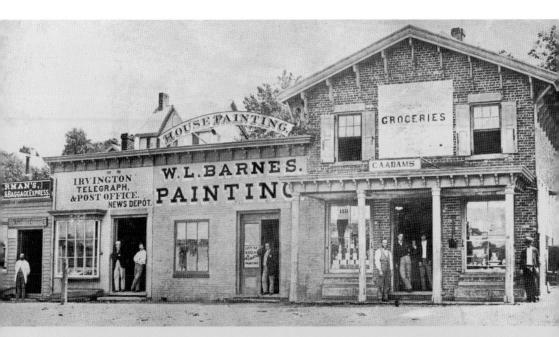

Justus Dearman purchased the 144 acres of the Dutcher farm nearest the dock in 1812, and the settlement became known as Dearman. In 1850, a year after the railroad arrived, the property was subdivided and sold at auction. Irvington's earliest commercial establishments, shown here in 1865, stood on Astor Street facing the dock and depot. They burned in 1881, and the site is now a parking lot.

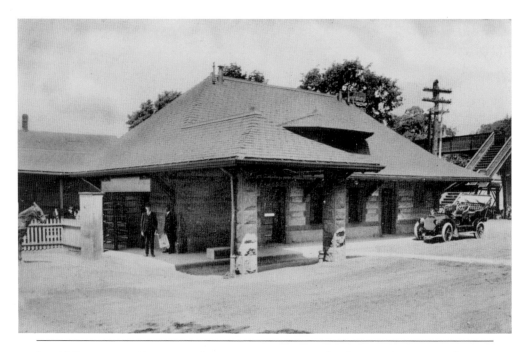

In 1853, two well-connected summer residents, George Denison Morgan and Moses H. Grinnell, facilitated naming the depot and post office Irvington in honor of the community's most famous resident. Grinnell, founder of the maritime firm Grinnell, Minturn and Company, was Washington Irving's nephew-in-law. Morgan, a banker, was a partner and cousin of Edwin Denison Morgan, a state senator at the time and later a U.S. senator and governor of New York. This is the second depot, built in 1890 and photographed in 1918. (Vintage photograph courtesy of Patricia Arone.)

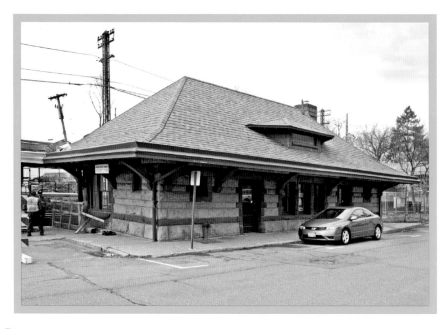

STROLLING MAIN AND THE ALPHABET STREETS

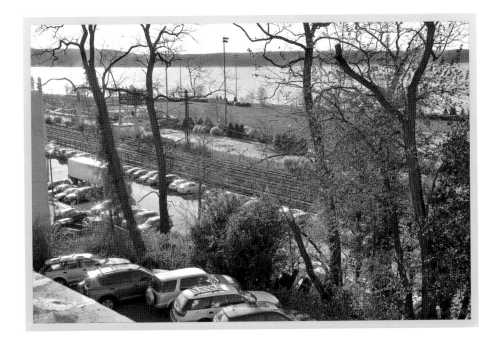

Scenic Hudson Park opened in 2001 on 12 landfill acres west of the railroad tracks. From 1895 through the 1960s, it was the site of J. C. Turner Cypress Lumber Company, which had offices in Manhattan and ships that sailed around the world. The 1914 photograph shows track nine in the foreground, which is now a parking lot. The park offers ball fields, a senior center, and breathtaking views stretching south to Manhattan, west across the Hudson River, and north to the Tappan Zee Bridge.

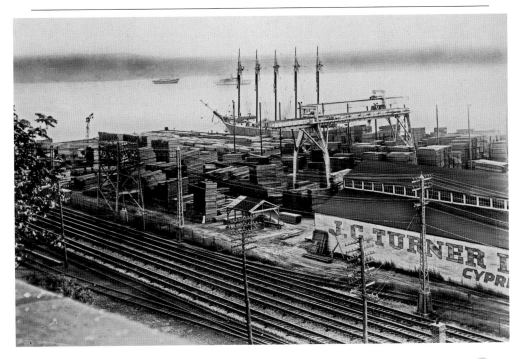

In 1860, Charles Lewis Tiffany, the "king of diamonds," purchased 65 acres north of Bridge Street between Broadway and the Hudson River from cousin and former partner Jabez L. Ellis. The photograph is dated 1887. The estate was called Tiffany Park until it was sold in 1902 to the Matthiessen family, which had owned a 17-acre estate adjoining to the north since 1865. The Tappan Zee Bridge in the background was completed in 1955 at the widest point of the Hudson River.

STROLLING MAIN AND THE ALPHABET STREETS

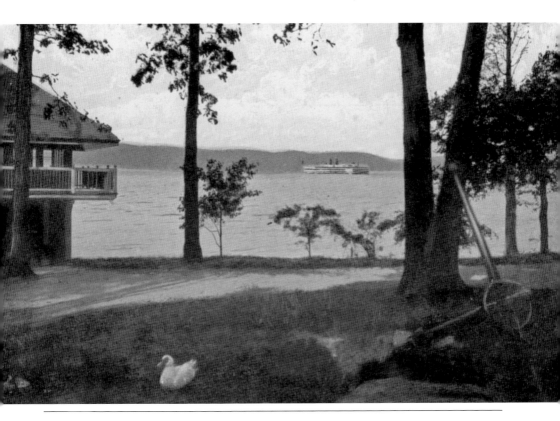

The Matthiessen family anchored a yacht at a dock off three acres west of the railroad tracks. Ralph Matthiessen permitted public use of this waterfront parcel, photographed in 1908, for a children's playground before donating it to the village as parkland in 1945. The shoreline was subsequently altered with landfill. Subdivision of the combined Tiffany-Matthiessen properties began in 1910; both this little park and the adjacent large residential neighborhood are now known as Matthiessen Park. (Vintage photograph courtesy of Jane Faber.)

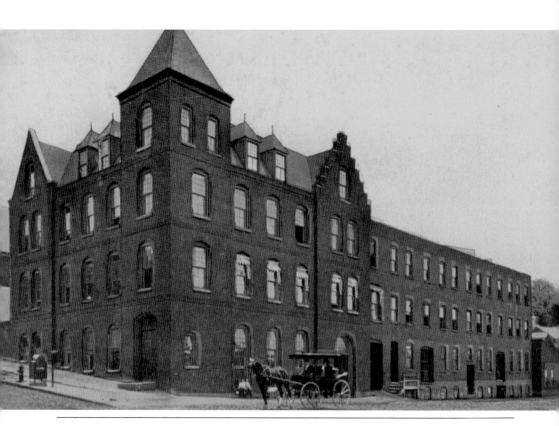

A mill, slaughterhouse, and cattle yard operated at 12 South Astor Street prior to 1870, when Lord and Burnham Horticultural Architects and Builders erected offices and a factory on the site, then replaced them after an 1881 fire with this structure, photographed in 1905. The firm closed its Irvington greenhouse factory in 1988, and the building stood vacant until transformed in 2000 into the Irvington Public Library and 22 units of affordable housing. The Lord and Burnham Building is listed on the National Register of Historic Places. (Vintage photograph courtesy of Edward Tishelman.)

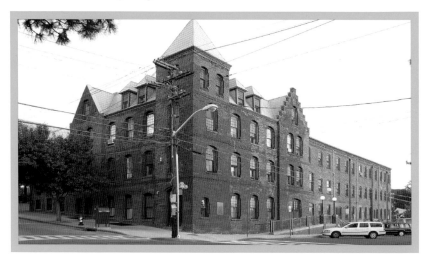

William Burnham had five attached redbrick townhouses built at 10–16A North Buckhout Street in 1900, when this photograph was taken. Classically styled with English basements and bay windows, they were designed for foremen of the Lord and Burnham greenhouse factory nearby. Prolific local builder Richard Behrens is pictured third from right during the construction.

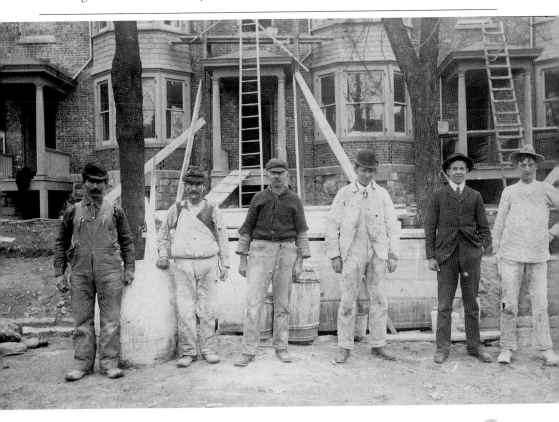

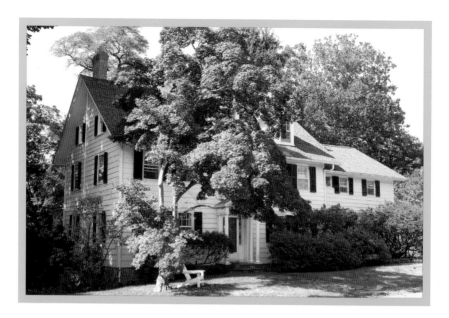

John Buckhout, tenant of the Philipsburg farm lying between Harmse's and Dutcher's, built his house on a knoll overlooking the Hudson River. After the American Revolution, the property passed to his grandson William Jewell and remained in the family for generations. The house was moved to 26 Barney Park (at the end of South Cottenet Street) around 1894 to make way for the Cosmopolitan building. According to village historian Arthur C. Lord in 1939, bones from a forgotten African burial ground were discovered during excavation.

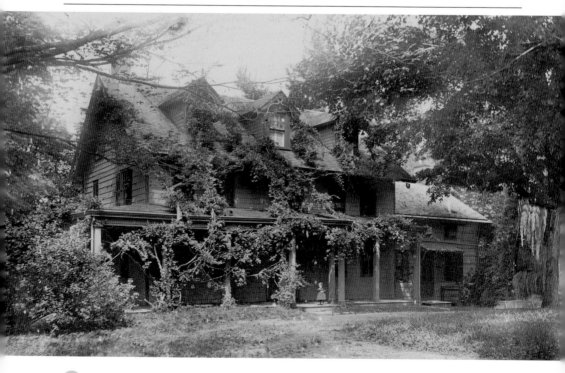

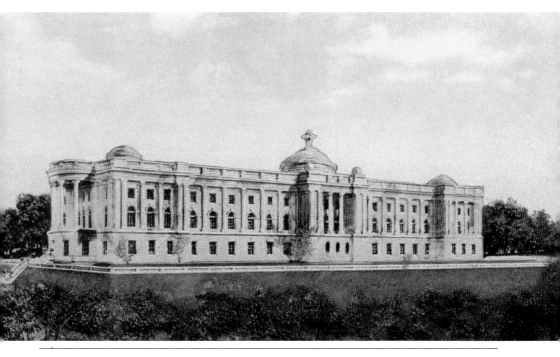

The Cosmopolitan building at 50 South Buckhout Street, attributed to Stanford White, was built in 1895 for John Brisben Walker, founder and publisher of the literary magazine and partner with Amzi Lorenzo Barber in producing one of the earliest automobiles. Walker purchased the farmhouse and its land from an interim owner, D. N. Barney. William Randolph Hearst bought the magazine in 1905, the date of this photograph, and moved it to New York City four years later. The building has since undergone many changes. (Vintage photograph courtesy of Edward Tishelman.)

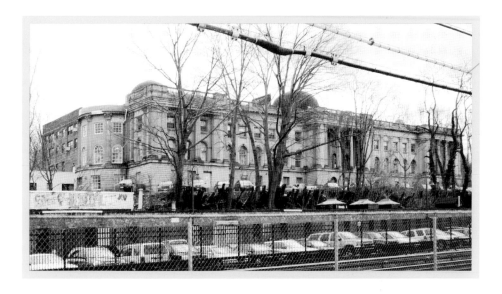

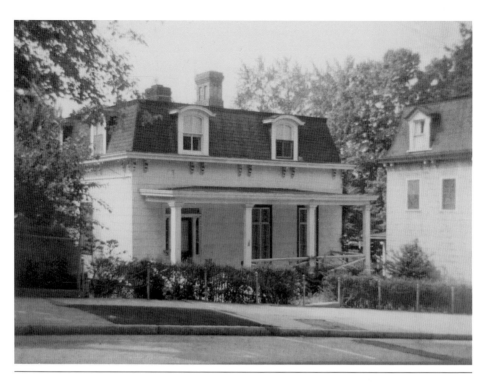

William Telbrock Crisfield, the first Irvington village clerk, bought this Main Street dwelling, which was built around 1865, from John Acker (of the Ecker/Eckar/Acker family) in 1881. It remained in the Crisfield family until purchased in 1955 by the present owners, Robert and Marion Connick. Robert's uncle, Tom Connick, married a Crisfield, preserving a family connection to the homestead. The house remains as built except for replacement of columns and flooring on the front porch. (Vintage photograph courtesy of Robert and Marion Connick.)

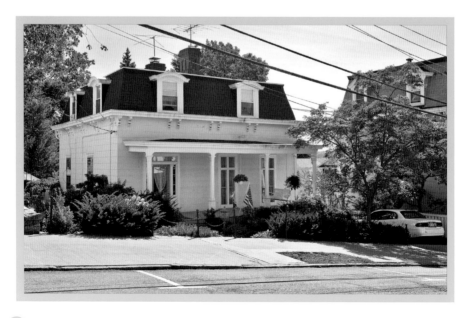

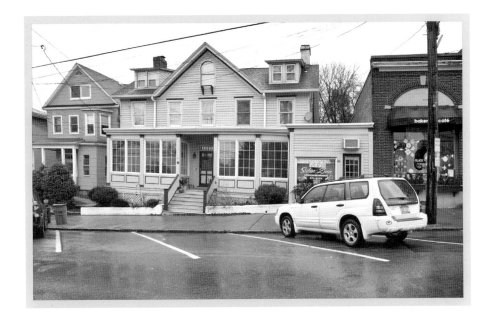

Seen here in 1915, 39 Main Street was the home of Duncan Grieg Smith, a mayor of Irvington who was born in 1900 in this house, which his father, Robert, a Scotch immigrant, built. The house stayed in the family until 1998, when Pat and Tony Matero opened the River Gallery on the first floor. Old-timers remember Robert Smith relaxing on the porch with his parrot, who liked to whistle at girls walking by. (Vintage photograph courtesy of Pat and Tony Matero.)

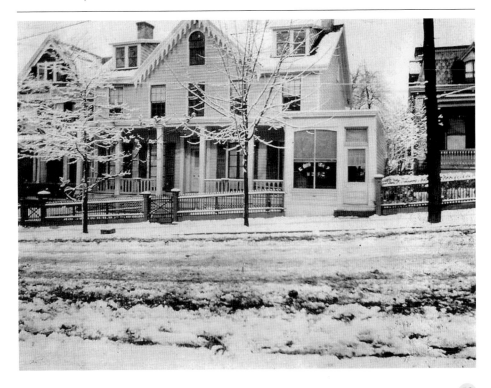

The Irvington Pharmacy, built in 1875 at 46 Main Street by pharmacist John Best, was a hub of village life, as seen here in 1910. In 1917, pharmacist John H. Barr advertised "pure drugs and chemicals" and "prescriptions compounded at all hours, day or night." Another long-term owner/pharmacist was Ted Gnatowski (c. 1947–1973). The pharmacy closed in 1999. After a sensitive updating, the building reopened in 2000 as TraLaLa, a toy and furnishings shop for children.

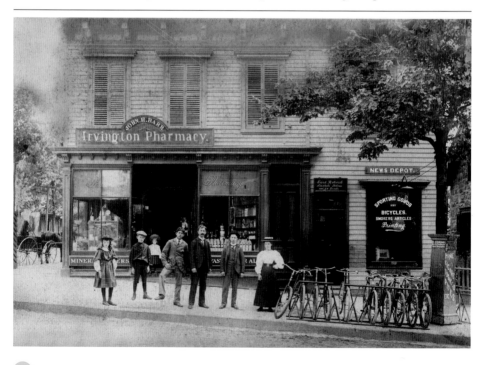

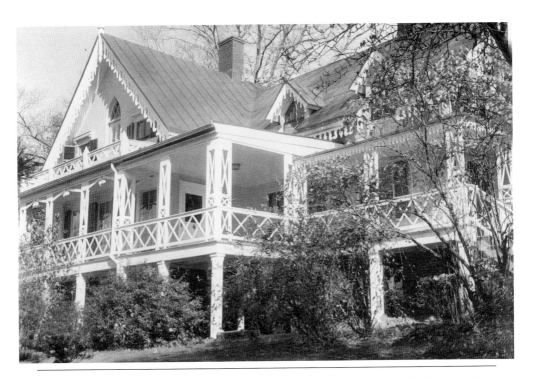

Built around 1843 as a summer home for Rev. Stephen H. Tyng, rector of St. George's Episcopal Church in New York City, 19 North Cottenet Street is remarkable for its riotous bargeboards and verandas. Later owner Robert Gardner Abercrombie named this large house Airdrie Cottage. Airdrie is a place name, as is Abercrombie, in the Council of Fife near Edinburgh, Scotland.

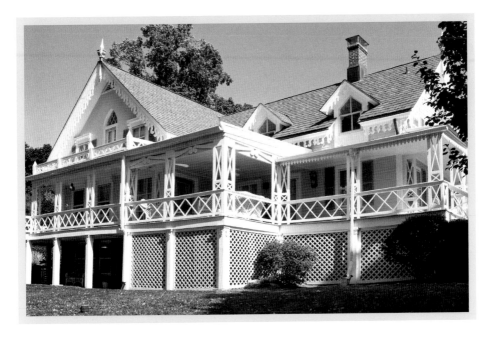

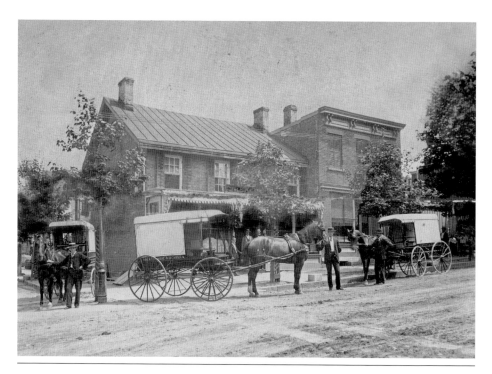

In 1852, Robert Gardner Abercrombie established a grocery store near the depot. Eighteen years later, he moved the business to 49–51 Main Street, seen above about 1900. His son Robert Gardner Abercrombie Jr. took over in 1882 with George E. Dearman as partner. In 1902, Robert Gardner Jr. turned his interest over to his brother Fred, founded the Irvington National Bank, and became president of the village. In 1904, a new three-story brick building was erected on the site in two sections, maintaining the grocery business in one while constructing the other.

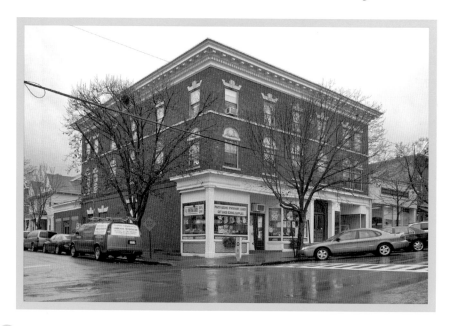

STROLLING MAIN AND THE ALPHABET STREETS

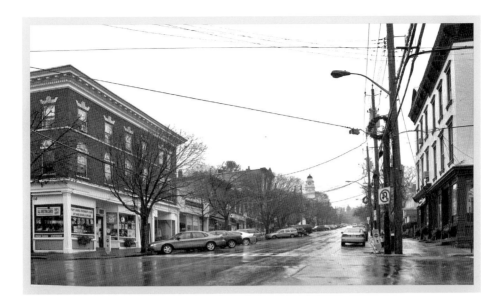

The business district evolved to service Irvington's estates, including establishments such as retail and tradesmen's shops, Abercrombie and Dearman, purveyors to the carriage trade, and the Lord and Burnham greenhouse factory. In the mid-20th century, the Abercrombie building (seen in the left foreground) housed Gristede Brothers, now Irvington Stationery at No. 49, and an art gallery next door. Nearly all the buildings shown here in 1907 are still on Main Street between Dutcher and Eckar Streets. (Vintage photograph courtesy of Edward Tishelman.)

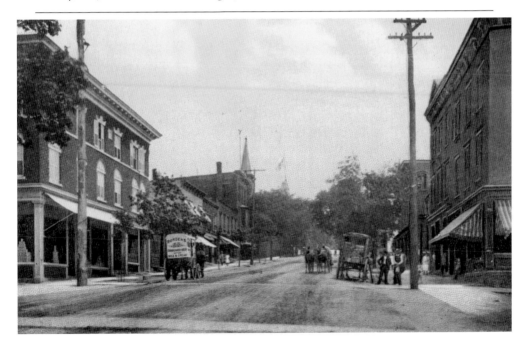

The Irvington Post Office was established in 1853 in Charles Adams's feed and general store on North Astor Street across from the railroad depot. Before settling into its present home at 25 North Buckhout Street in 1958, it moved at least eight times, including back and forth more than once between 48 and 50 Main Street, which have nearly identical first-story facades. This undated photograph may picture 50 Main Street, site of the post office when letter carrier service was established in 1902.

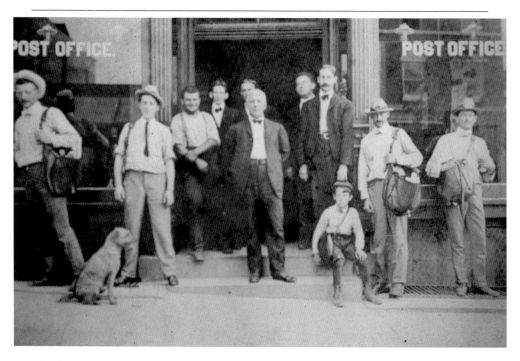

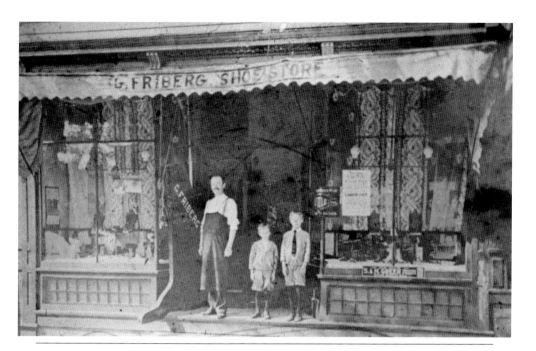

The Friberg Shoe Store opened here at 57 Main Street in 1886. Clarence Becker and his son Marvin operated Becker's Stationery Store here from 1924 to 1974; their family lived upstairs. Dave and Ann Walsh had a long tenure as well, selling stationery and gift items from 1986 to 2004. The storefront was remodeled in the mid-20th century. The interior was refitted for River Vue, a gourmet food market, in 2007.

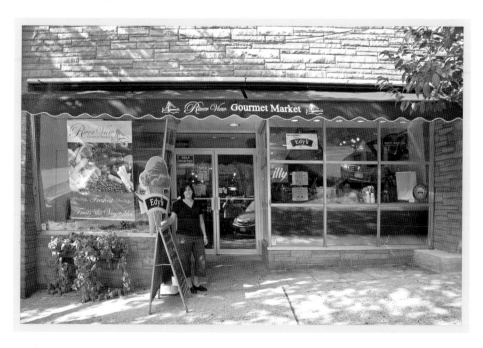

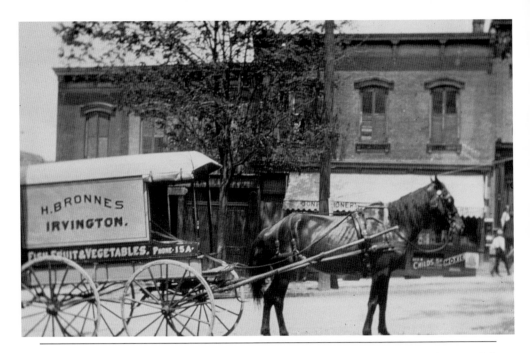

A vacant lot in 1881, a clothing store in 1889, Michaely's Barber Shop in 1900, a confectionery when this undated photograph was taken, and a Grand Union from 1940 to 1980 (Irvington's only ever national chain store), 61 Main Street is now Geordane's Market (right). At left was Peter Laffan's Paint; now it is All that Glitters Jewelry. Harry Bronnes's fish, fruit, and vegetable market stood opposite on the south side of the street.

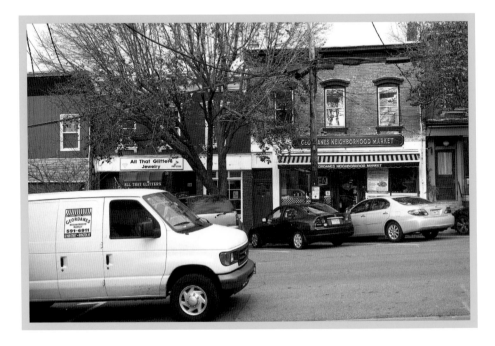

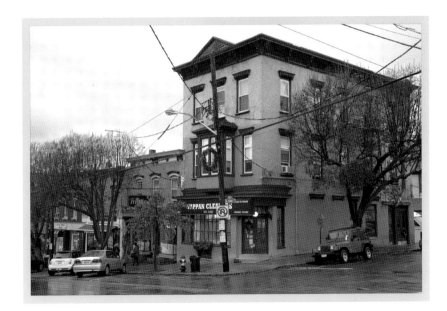

Occupied on the first floor by Tappan Cleaners for the past half century, the building on the northwest corner of Main and Eckar Streets was built about 1886 as Adam Busch's Hotel and Bar, one of several workingmen's saloons that annoyed their sober neighbors. In that decade, the other stores seen here included a barbershop, a clothing store, and Peter Laffan's Paint. During most of the 20th century, the DeChiara family operated various food-related businesses at 63 Main, now occupied by Mima Vinoteca. (Vintage photograph courtesy of Jim Parker.)

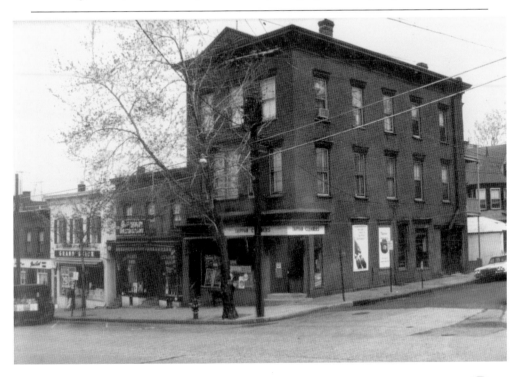

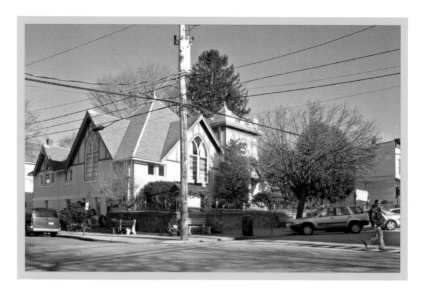

St. Paul's Methodist Church was built about 1860 and burned in 1908. The second church was built in 1909 on the same site at 44 Main Street and has served as the Isabel K. Benjamin Community Center since 1962 after St. Paul's merged with Summerfield Methodist Church of Dobbs Ferry. Known as "a first lady of Irvington," Benjamin was the daughter of the second rector of St. Barnabas Episcopal Church. She led the Irvington Girl Scouts—and much else—for almost 40 years.

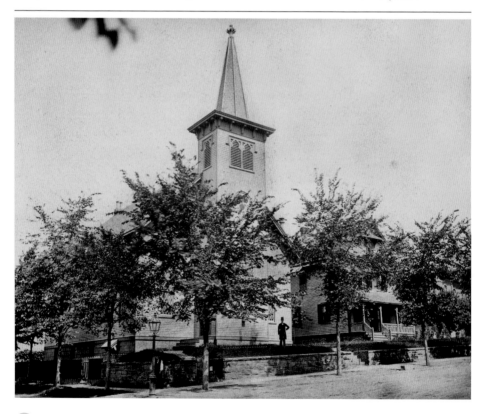

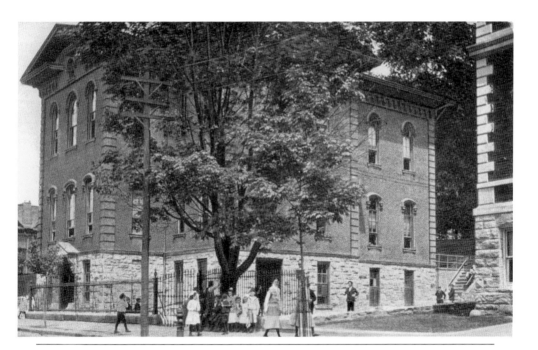

Irvington's first public school was organized in 1856 in a long-gone building on Broadway just south of Main Street. By 1874, that building was outgrown, and a new schoolhouse, pictured here in about 1910, was built on North Ferris Street on the site of a house that was moved to the corner of West Home Place and South Ferris Street. High school classes were added in 1898. The building was demolished in 1913 and later replaced by the Main Street School gymnasium behind town hall. (Vintage photograph courtesy of Patricia Arone.)

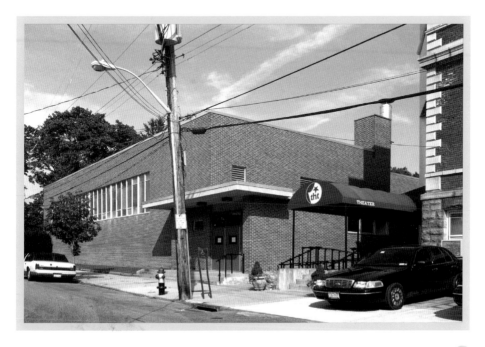

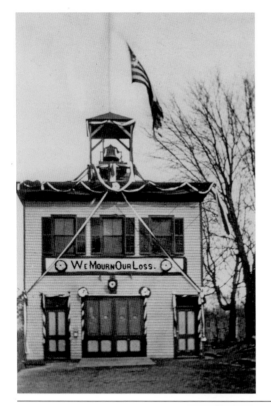

The Irvington Fire Association was organized in 1880 in a rented building at the dead end of North Ferris Street, as photographed about 1894. The banner honors a deceased fireman. When the firemen relocated to town hall in 1905, this building was moved to 27 North Ferris Street and remodeled as a home, and Ferris Street was extended into Matthiessen Park. The 1883 fire bell now adorns the lawn of the 1965 firehouse at 90 Main Street.

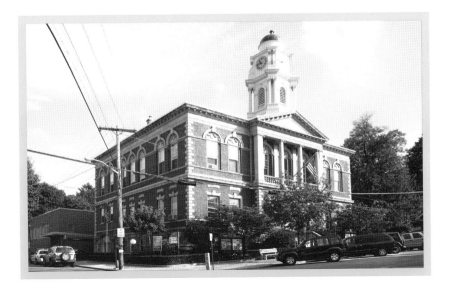

In 1866, the Mental and Moral Improvement Society erected the Sunnyside Atheneum free library, seen at left in this 1869 photograph, at the east corner of Main and North Ferris Streets. Overflow books were shelved in Thomas Kemble's store next door. The society donated the site for the town hall (opened 1902), mandating a reading room and assembly hall. The reading room, designed by Louis Comfort Tiffany, is one of the few Tiffany interiors that remain intact; the assembly hall is a venue for performing artists. Town hall is listed on the National Register of Historic Places.

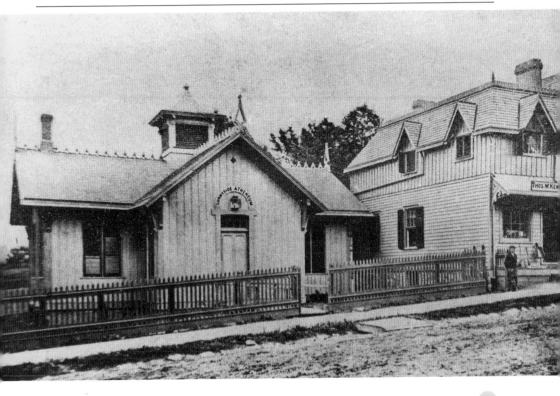

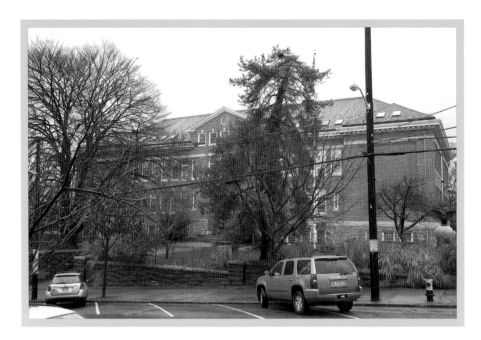

Irvington's third schoolhouse, the Main Street School, was built in 1913 and had doubled in size when this 1941 photograph was made. Enlarged again while still serving kindergarten through 12th grade, it later accommodated the middle school and, since 2003, has housed fourth and fifth grades only. The school was built on the estate of William Orton (1826–1878), who began life with few advantages yet became president of Western Union Telegraph Company by 1867.

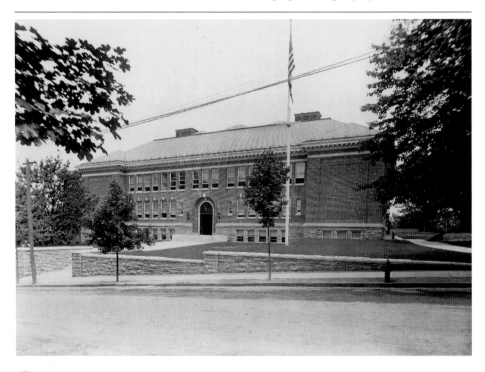

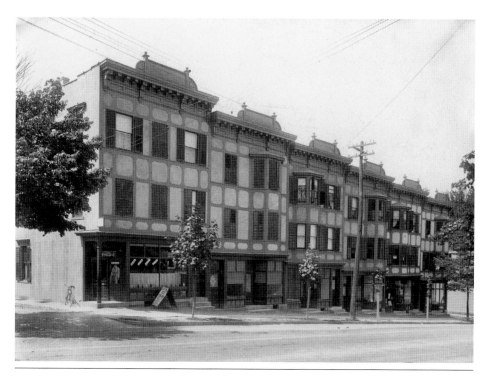

The Behrens Block, a mixed-use building at 98–106 Main Street designed to resemble six attached townhouses, was built in several stages from 1905 to 1910 by Richard Behrens. Behrens Park was built in the same period on adjoining streets to the south. The site had been cleared about 1902, when the home of singer/translator Helen D. Tretbar (wife of Charles F. Tretbar, music publisher and treasurer of Steinway and Sons) was moved to the east side of South Ferris Street.

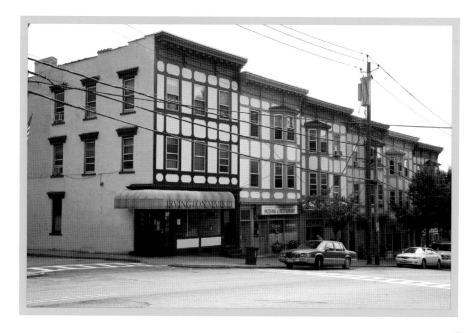

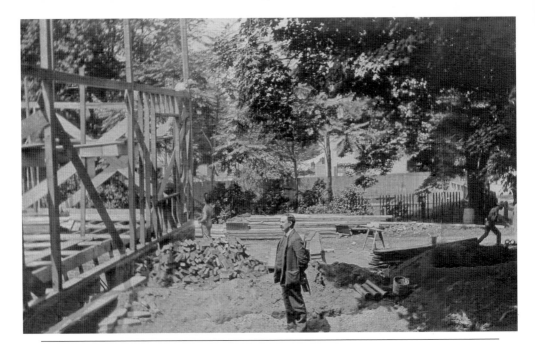

Upon graduation from medical school in 1895, Evan Jones Smith was invited to Irvington by school superintendent R. A. McDonald, who wrote, "There is no doctor here and a good many sick people." Smith made both his home and office at 116 Main Street, seen here in 1896, under construction as the doctor looks on. His son Dr. Chesley Evan Smith continued the medical practice in this dwelling until 1962. (Vintage photograph courtesy of Jennifer O'Connell.)

STROLLING MAIN AND THE ALPHABET STREETS

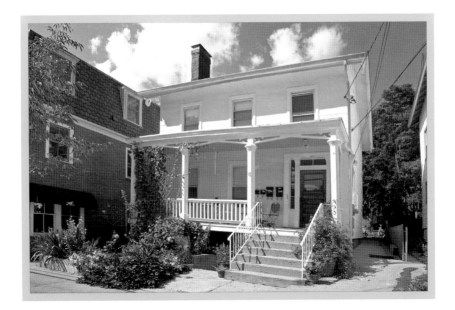

The home at 117 Main Street is typical of the vernacular cottages that lined the street in the late 19th century—and to a considerable degree still do, alongside the largely intact small commercial buildings of the same period. While some remain one-family residences, others have been converted for multiple-family use or have offices on the ground floor. Assistant postmaster Gerald Reilly and his wife, Alice, lived here for several decades in the 20th century. (Vintage photograph courtesy of Irvington Historical Society.)

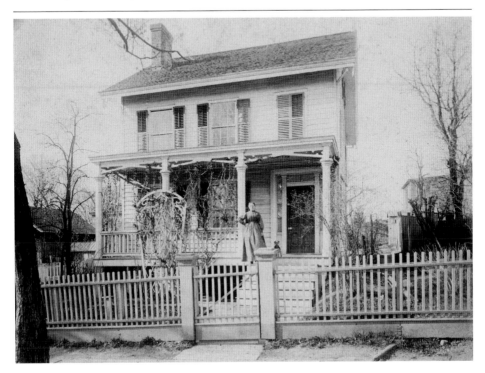

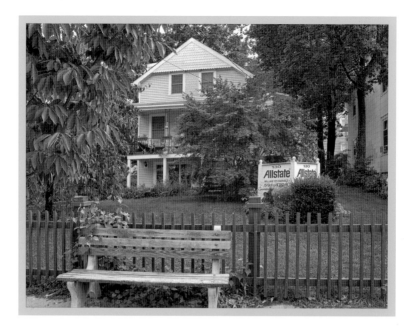

Justus Dearman built this house at 130 Main Street about 1812, nearly four decades before his farm was laid out as a commercial center fetching an average of $2,000 an acre at auction in 1850. Some sources say the house seen at right in this 1890 photograph is of Colonial vintage.

Posing out front are Mrs. Sylvester Buckhout (descendant of John Buckhout, another Philipsburg Manor tenant) and daughters Sadie (on stoop) and Lulu (in yard). An insurance agency now occupies the ground floor.

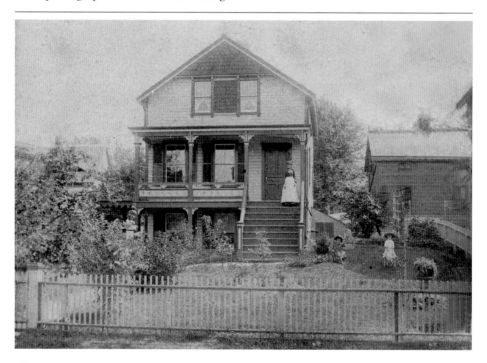

STROLLING MAIN AND THE ALPHABET STREETS

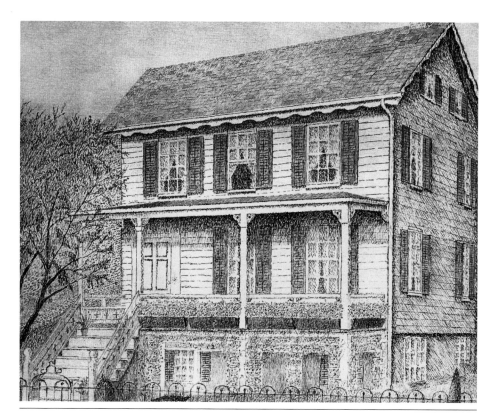

The headquarters of the Irvington Historical Society at 131 Main Street was built in 1853 on land owned from 1850 to 1870 by Rev. John McVickar and Rev. William McVickar. There were many subsequent residents, including the Fallon family from 1935 to 1967. Con Edison built a substation in the backyard in 1957, and Dr. Mario Dolan maintained a medical office there until 1984. Abandoned in 1992, the house was restored by the society between 2002 and 2005. It is listed on the National Register of Historic Places. (Vintage photograph courtesy of Irvington Historical Society.)

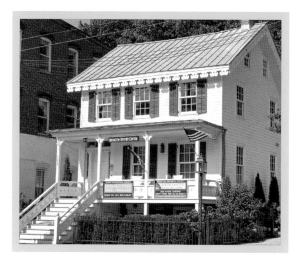

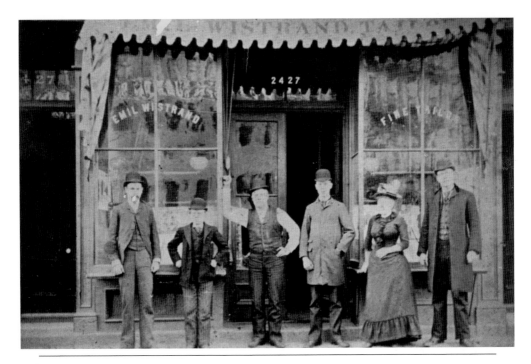

In 1889, grocer John Dinkel's former clerks, Buckley and Raban, operated a grocery on Broadway at the northwest corner of Main Street, with Emil Wistrand's tailor shop immediately to its north. Wistrand, a village trustee, also operated Irvington's first movie theater at the west corner of South Ferris and Main Streets. The Lambros Service Center—an expansion of Joe Schunk's early gasoline station—now occupies the entire stretch of North Broadway from Main Street to the property line of the Church of St. Barnabas.

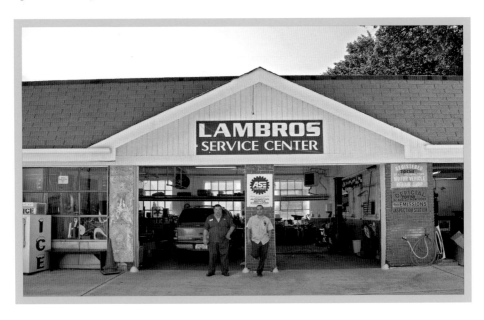

STROLLING MAIN AND THE ALPHABET STREETS

EXPLORING NORTH BROADWAY

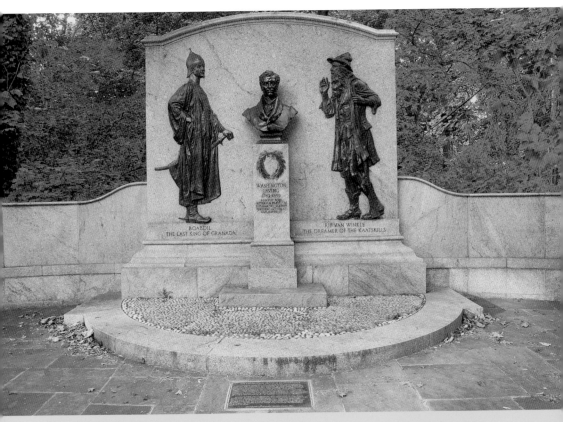

The Washington Irving Memorial, made of bronze and set in a pink granite setting, was installed in 1927 at the corner of Broadway and Sunnyside Lane, climaxing a 20-year campaign by longtime resident Jennie Prince Black to honor Irving within village limits. Daniel Chester French, designer of the Lincoln Memorial, sculpted the bust of Irving and the reliefs of his characters Rip Van Winkle and King Boabdil. The memorial is listed on the National Register of Historic Places.

Irving Cliff was built in 1869 for Eliphalet Wood, "the lumber king," at the highest point overlooking the Hudson River (now 60–70 Ridgeview Drive). It was entered from Broadway alongside the Catholic church. Wood named the estate for his famous friend, who enjoyed its views of the Hudson River. The castle, built of stone quarried on the property, passed to his grandson J. Wood Rutter, a stockbroker, and remained in the same family without alterations until it was destroyed in 1983 for the construction of Fieldpoint Condominiums. (Vintage photograph courtesy of Irvington Historical Society.)

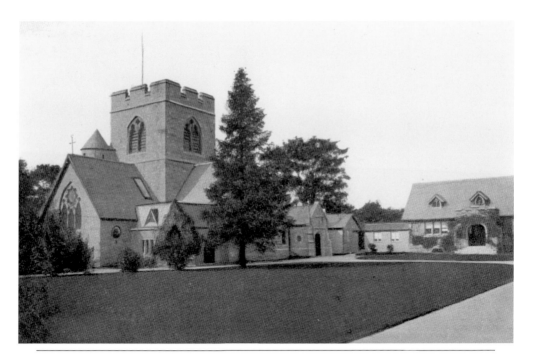

In 1853, Rev. John McVickar, an Episcopal priest and professor at King's College (Columbia University), built the Chapel School (now the nave of the Church of St. Barnabas) on land along North Broadway acquired at the Dearman auction. To the right of the church edifice is the 1902 Parish Hall, designed by A.J. Manning. The parish was incorporated in 1858, the school was dedicated as a church, and McVickar's son William became the first rector. The tower, transept, and chancel, designed by James Renwick, were added in 1863, followed by many additions and adornments. The church is listed on the National Register of Historic Places. (Vintage photograph courtesy of Edward Tishelman.)

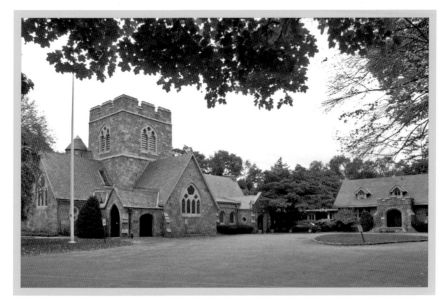

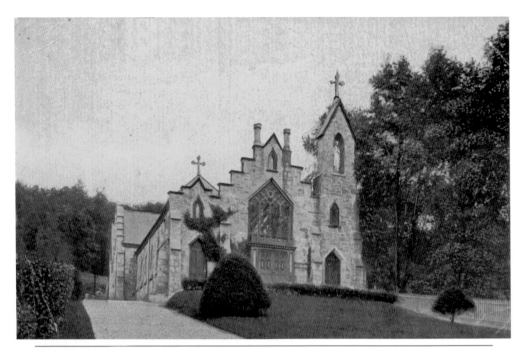

The Presbyterians' first church was built in 1853 on the east side of Broadway. The Immaculate Conception Church congregation bought it in 1872, abandoned it after a 1970 fire, and built a new church nearby. The ruins were pulled down in 1996; the residence at 31 Matthiessen Park Road incorporates some salvaged stone. The site is now a parking lot behind the former rectory (now ICC Pre-Kindergarten) near 16 North Broadway. (Vintage photograph courtesy of Patricia Arone.)

Irvington Presbyterian Church, located at 25 North Broadway, is the congregation's second building and was designed by James Renwick and dedicated in 1869. Jay Gould, Cyrus W. Field, Charles Lewis Tiffany, and George Denison Morgan were the principal contributors. Some 185 stained-glass windows by Louis Comfort Tiffany were installed in 1913, and Whitechapel carillon bells were added in 2007. The manse was built in 1900 on land donated by Gould. The original spire was damaged by the 1939 hurricane and removed; the existing spire was built in 1966.

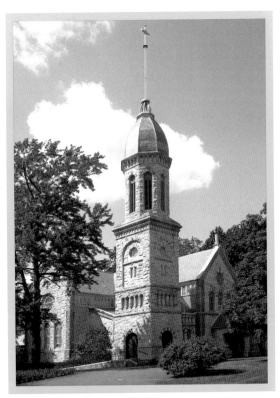

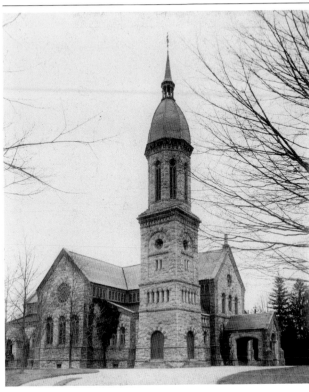

Charles Lewis Tiffany's 65 acres included the Dutcher farmhouse. He dubbed it Tiffany Hall, a jab at the faux castles other millionaires were erecting at that time. Demolished sometime between his death in 1902 and 1924 (accounts vary), the house stood at the end of the long driveway from Broadway along the northern boundary of the Presbyterian church, slightly north of this residence built at 31 Matthiessen Park Road about 1996. The northwesterly facades of both dwellings are shown here.

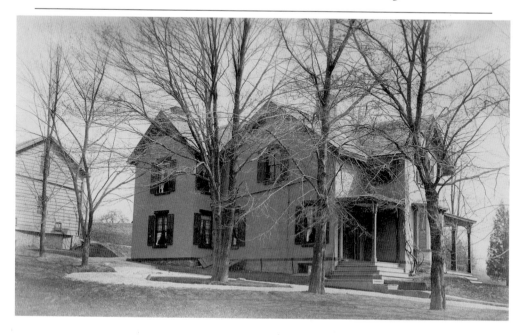

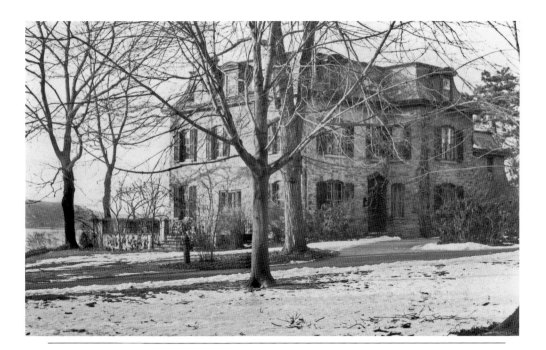

By 1881, Tiffany had added to his estate several acres previously owned by James L. Dunham, an in-law and business associate, along with Dunham's two 1866 yellow-stone mansions south of the driveway to Tiffany Hall. Both mansions remain, facing each other across what was originally a circular drive; the one nearest to the river is pictured here. Son Louis Comfort Tiffany spent childhood summers on the estate, his artistic sensibilities stimulated by the proximity to the Hudson River.

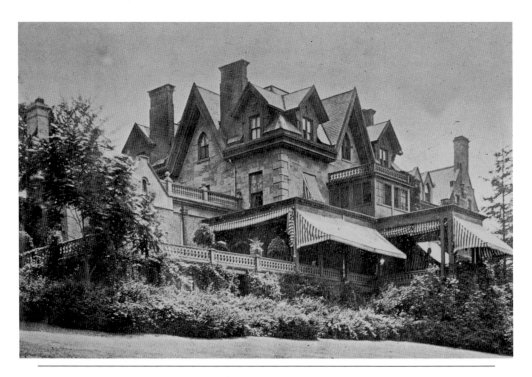

Around 1865, Francis O. Matthiessen, "the sugar king," bought 19 acres north of Charles Lewis Tiffany's estate and built a yellow-stone mansion (now 2 Fargo Lane). With his children having died young, the property went to his brothers and subsequently to nephew Erard Matthiessen upon his death in 1901. A series of remodelings begun in 1931 simplified the roofline and added redbrick wings to each end. It remained in the family until it was sold in 1941 to John H. Jones of Dobbs Ferry.

Upon the death of Charles Lewis Tiffany in 1902, Matthiessen's nephew Conrad Matthiessen bought the Tiffany estate. Conrad's son Ralph Matthiessen, founder of the General Time Corporation, built this house at 33 Matthiessen Park Road in 1925 on a site somewhat overlapping that of Tiffany Hall. Some ghostly traces of Tiffany Hall and the layout of its grounds remained into at least the 1950s. (Vintage photograph courtesy of Robert and Marion Connick.)

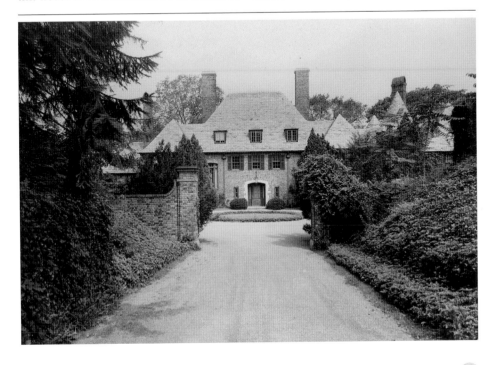

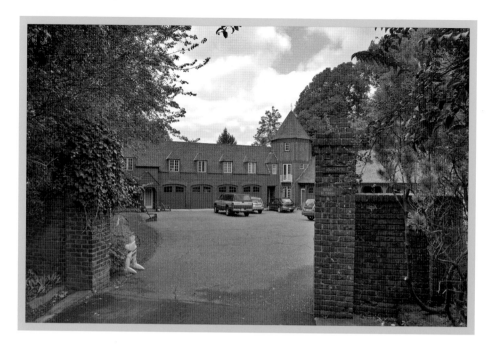

In 1950, the Ralph Matthiessen property—at that time owned by celebrities Mike Todd and Joan Blondell—was subdivided and sold. This building, which served as garage, stables, and lodging for the gardener, chauffeur, and kennel master, was bought by Charles E. Gamper, a diplomat, and his wife, Harriet, an avocational archaeologist, who remodeled the building into three spacious residences at 40–42 Matthiessen Park Road. (Vintage photograph courtesy of Robert and Marion Connick.)

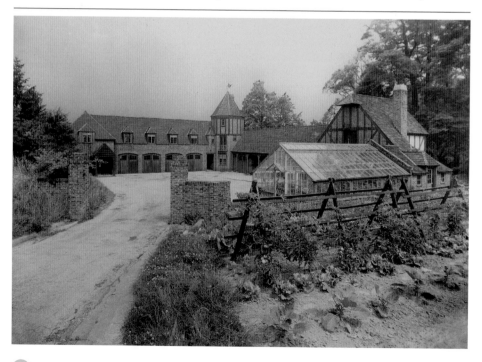

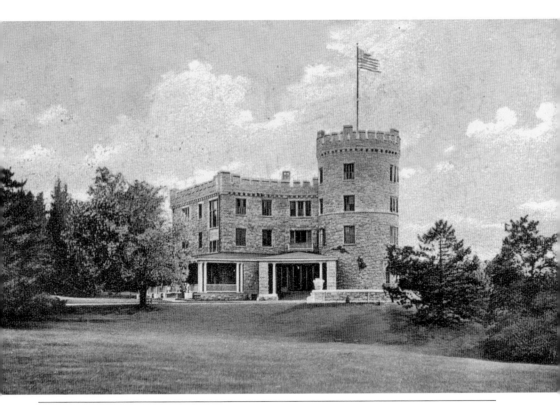

Augustus Corey Richards, a New York City merchant, built Ridgeview in the 1860s as a picturesque cottage with a tower. About 1900, dry goods entrepreneur Isaac Stern remodeled it, as seen here, and renamed it Cedar Lawn. Abandoned in the 1950s, it was razed in 1961 and replaced with the first wing of the new Irvington High School (right), opened in 1966 and enlarged in 2003. (Vintage photograph courtesy of Jane Faber.)

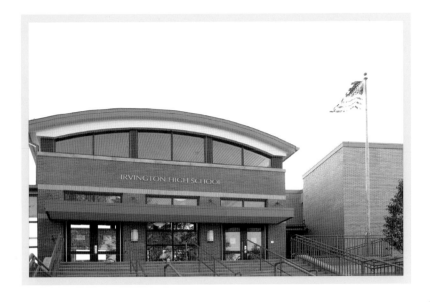

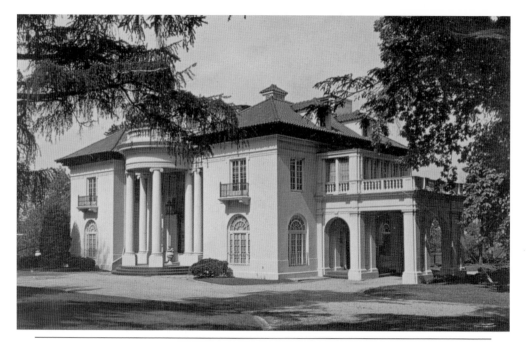

Vertner Tandy, New York's first registered African American architect, designed Villa Lewaro at 67 North Broadway in 1917 for Madame C. J. Walker, whose patented hair products made her the first African American millionaire. Lewaro—an anagram of Walker's daughter's name—stands on the site of John A. Bryan's pre-1870 Dernica Resort. Converted to the Annie E. Poth Home for Tired Mothers, Convalescents and the Aged by a fraternal organization in 1932, Villa Lewaro was restored as a private residence in 1993. It is listed on the National Register of Historic Places.

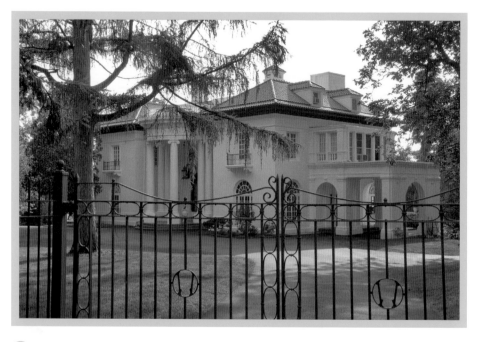

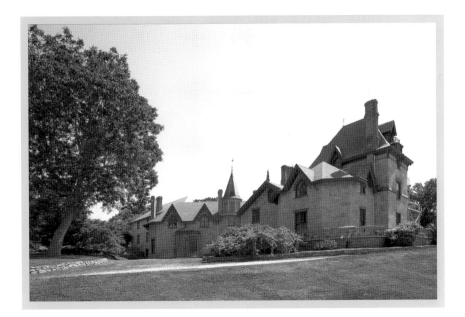

Strawberry Hill was built on 300 acres in 1850 for John Thomas, a wealthy, retired merchant about whom little is known save his death by lightning. By 1887, the date of this photograph, the estate had long been owned by his son-in-law John E. Williams, an English banker, who named it after Horace Walpole's Twickenham villa. The Eddison family was among subsequent owners into the 20th century. The mansion remains at 11–13 Strawberry Lane on five acres in a subdivision begun in 1923.

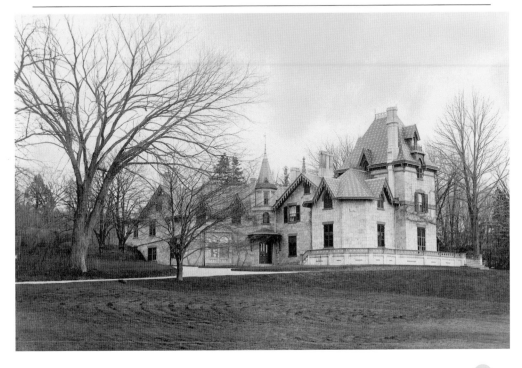

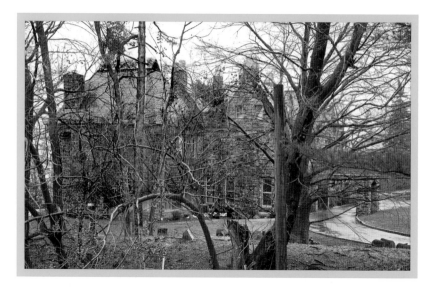

James Cunningham, steamboat engine manufacturer, designed Craig Hall between 1860 and 1863 as his retirement home but died before occupying it. Vacant for over a decade, it was refurbished by his daughter Florence and her husband, Heber R. Bishop, art collectors with a fortune built on sugar, railroads, and iron. It burned the night before they were to move in. In 1910, textile manufacturer Frederick Sayles salvaged its stones to build Chateau, seen here. Accessed from 50 East Sunnyside Lane, Chateau now belongs to Unification Church. (Vintage photograph courtesy of Patricia Arone.)

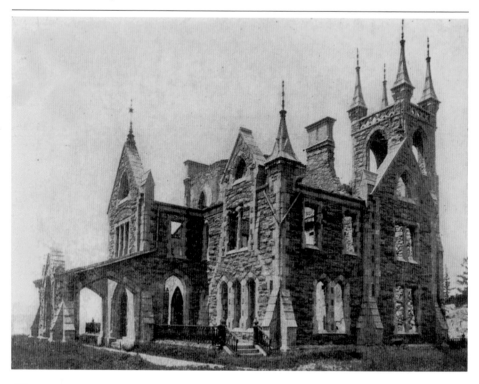

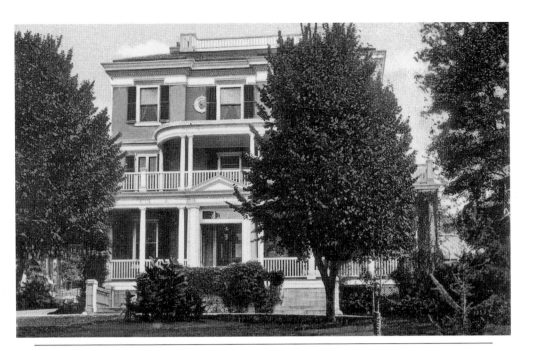

Repose, located at 106–108 North Broadway, was built about 1850 by Edmund Coffin, who began real estate operations in Irvington that year, capitalizing on the completion of the Hudson River Railroad line. Together with George Denison Morgan and Moses Grinnell, Coffin was a pioneer in the development of post-railroad Irvington. George E. Dickinson, a coal magnate, purchased the property around 1900 and named it Chatenay after a Paris suburb. Later used by the Hudson River Day School, Repose is now advertising agency offices. (Vintage photograph courtesy of Patricia Arone.)

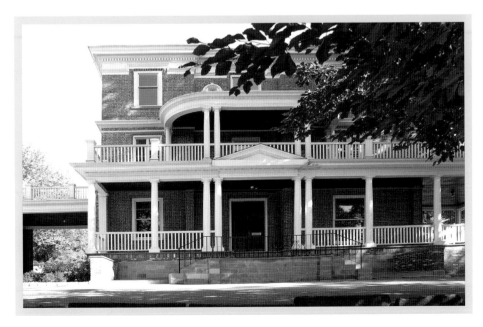

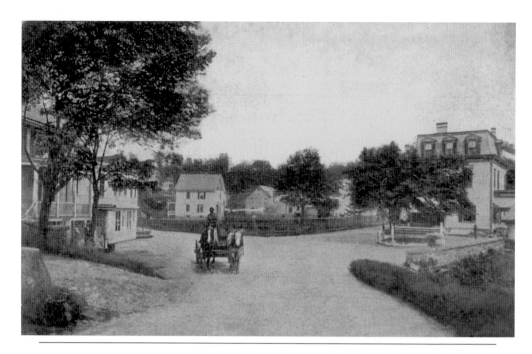

East Irvington, at the intersection of Taxter and Mountain Roads, was once known as Little Dublin, a tribute to its population of Irish immigrants; the name fell out of use as immigrants from other nations moved in. The small house near the center was built before the Civil War and is the longtime home of Eugene Russo, who recalls riding in Frank Colucci's junk wagon, also seen in the vintage photograph. (Vintage photograph courtesy of Patricia Arone.)

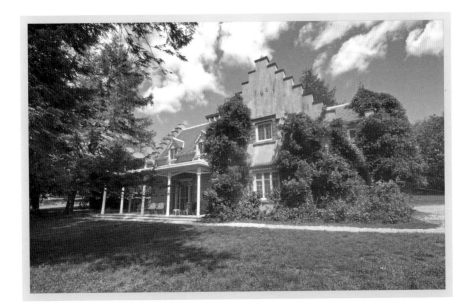

Seeking peace and quiet in the countryside, Washington Irving purchased the 18th-century Ecker/VanTassel farmhouse in 1835 and transformed it into Sunnyside, an idiosyncratic "snuggery" that has captivated visitors ever since. Located at the end of West Sunnyside Lane, the residence remained in his family until 1945 and is now owned by Historic Hudson Valley, a not-for-profit organization, and is open to the public. The west facade is shown in both images. The vintage image is from an 1835 painting by George Harvey, titled *The Old Cottage Taken Previous to Improvement*. It is used courtesy of Historic Hudson Valley, as is the contemporary photograph by Brian Haeffele.

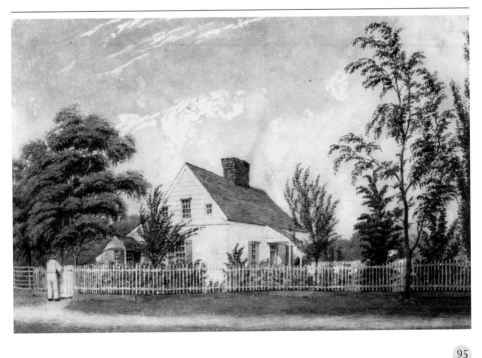

www.arcadiapublishing.com

Discover books about the town where you grew up, the cities where your friends and families live, the town where your parents met, or even that retirement spot you've been dreaming about. Our Web site provides history lovers with exclusive deals, advanced notification about new titles, e-mail alerts of author events, and much more.

MADE IN THE

Arcadia Publishing, the leading local history publisher in the United States, is committed to making history accessible and meaningful through publishing books that celebrate and preserve the heritage of America's people and places. Consistent with our mission to preserve history on a local level, this book was printed in South Carolina on American-made paper and manufactured entirely in the United States.

This book carries the accredited Forest Stewardship Council (FSC) label and is printed on 100 percent FSC-certified paper. Products carrying the FSC label are independently certified to assure consumers that they come from forests that are managed to meet the social, economic, and ecological needs of present and future generations.

FSC
Mixed Sources
Product group from well-managed forests and other controlled sources

Cert no. SW-COC-001530
www.fsc.org
© 1996 Forest Stewardship Council

Find Your Place in History.